-7887-0242-3
87-0243-0

of this book is available from the British Library.

y Design
nd by Levent Ofset

5 4 2

ul Joynson-Hicks and Tom Sullam, 2019
dividual photographers
athan Joyce

able effort has been made to trace copyright holders of material reproduced in this book,
ve been inadvertently overlooked the publishers would be glad to hear from them.

print of Bonnier Books UK
erbooks.co.uk

Published by 535
The Plaza,
535 Kings Road,
Chelsea Harbour,
London, SW10 0S

twitter.com/535bo

Hardback – 978-1
Ebook – 978-1-78

A CIP catalogue

Designed by En
Printed and bou

1 3 5 7 9 10 8

535 is an im
www.bonni

COMEDY WILDLIFE PHOTOGRAPHY AWARDS

VOL.3

CREATED BY
PAUL JOYNSON-HICKS AND TOM SULLAM

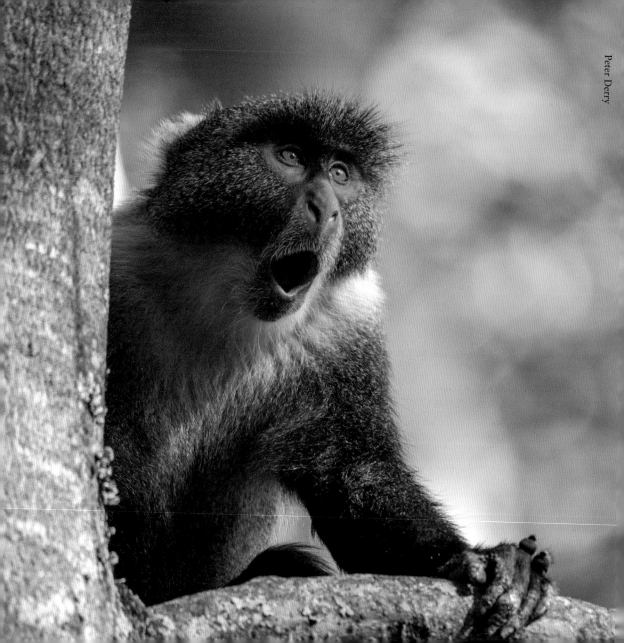

FOREWORD

BY WILL TRAVERS, PRESIDENT OF THE BORN FREE FOUNDATION

When we look at the natural world around us we could be forgiven for collapsing in a puddle of despair and weeping at the devastating impact the human species is having on everything else. Climate change, extinction crisis, trophy hunting, wild animals kept as 'pets', circuses, dolphin shows, roadside zoos, the ivory trade, people posing with wild animals for the dreadful 'selfish-selfies' – ok, I am already sobbing!

It doesn't have to be this way. We all know that there are things we can individually do to help reverse the human tide of destruction, and we also know that connecting with nature has positive impacts on human mental health, our emotional integrity and on our physical well-being. Nature is a great healer, but there's more. The natural behaviour of wild animals 'doing their thing' can actually make us laugh out loud – delivering what I can only describe as a 'natural high'!

Now, some of the world's best-loved, rib-tickling images – entrants and winners of the Comedy Wildlife Photography Awards – have been brought together into a book (the third

in the series) to make your upper lip tremble with delight, accentuate the laughter-lines around your eyes, and bring genuine tears of joy.

I am super lucky to be one of the judges for the annual Comedy Wildlife Photography Awards and so I have had the enormous pleasure of seeing hundreds of the very best images, and sharing with my fellow judges the almost impossible task of choosing the winners. Everyone says that judging is a tough job but how can I possibly resist a swan seemingly shouting "cannonball!" to his unsuspecting friends? How can I not burst out laughing at the sight of a lion cub about to grab his father's most prized assets? And how on earth can I choose between these and all the others? They are all winners!

Behind the smiles and the giggles there is a serious message. As the co-founder of the Born Free Foundation, for 35 years I have witnessed the pressures we relentlessly impose on the natural world, the conservation challenges we cause, and the abuse and suffering wild animals endure because of us. It can be depressing and people often ask me if there is hope and I say – always. Why? Because while human beings have an almost infinite capacity for stupidity, thoughtlessness and cruelty, we also have an even greater capacity for kindness, altruism, appreciation and compassion. And the next generation seems to be way ahead of us. Whether it's the millions of young people taking part in Climate Strike; or marching and speaking at rallies against trophy hunting, whaling, plastic pollution or palm oil; or calling out current world leaders for simply failing to take the planet's plight seriously – young people are on the move.

So if you want to crack an 'all-natural smile' then settle back and turn the pages of this book – and then, in return for that happy feeling, pledge to get out there and do one good thing for our planet, thereby helping ensure that there'll be plenty to giggle about for generations to come.

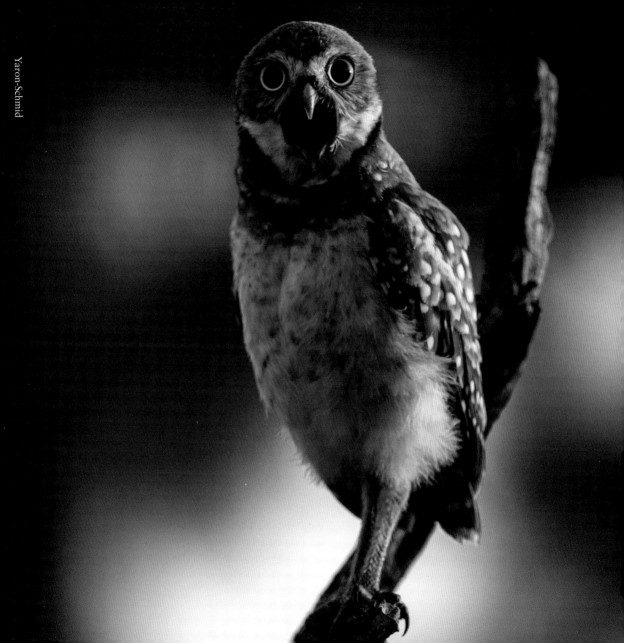

INTRODUCTION – CONSERVATION THROUGH COMEDY

Welcome to our third book! Holy mackerel, what a year it has been! Our entries from 2019 have been the best ever. It has been a humungous battle choosing the winners and thankfully the judges have had that arduous task, but the best thing about this awesome tome is that we get to showcase more fantastic images than just the 40 finalists and winners, so great news all round.

One of the most satisfying aspects of this year's competition has been the breadth of species and behaviour that were photographed. There are some animals that never fail to provide entertainment, and we certainly do not tire of seeing the same animals in hilarious situations, I mean seriously, what is it about the snow macaques, which makes them always throw us the finger? Perhaps they have had enough of us? And you just have to love the laughing seals, they can't help it, they love to chuckle. But it is also very uplifting to see images of species doing things we haven't seen before – matrimonial cape squirrels, dancing lions in front of a crowd of rather nervous wildebeest (presumably they will be getting 10s all round?), a chillin' chimp and a tree-eating squirrel, all spectacular.

But what are we all about? In case you are coming to this book and our little photography competition for the first time, or you have, which is more likely, totally forgotten about us and have encountered us in your desperate search for a Christmas present for Great Aunt Helga, here is a little background. We – and 'we' in this case is the huge corporation of the Comedy Wildlife Photography Awards, which is manned by Tom and Paul and basically run by Michelle, who we all know is the real boss – are all conservationists and thought that this photography competition and subsequent coverage was a great opportunity to tell the world about conservation issues and what we can do to help from our homes.

Most importantly we are using humour to send a positive message about conservation issues. We are all aware of the desperately sad images of dead animals, destroyed forests and slaughtered sharks and the world needs these images to keep reminding us of the massive problems our planet is facing, but we have our little role to engage with people, hopefully, around the world, with our message of conservation in a positive and funny way. At the back of the book or online, you will find a few top tips for things you can do to be a radical conservationist at home, and seriously, it ain't that much! Let's make the world feel a little bit better, bit by bit.

Thank you, for buying this book, and if you received this book, thank you for receiving it and, note to self, buy loads of them in the future for other presents!

With very best wishes from all three of us at Comedy Wildlife Photography Awards,

Paul, Tom and Michelle
info@comedywildlifephoto.com
www.comedywildlifephoto.com

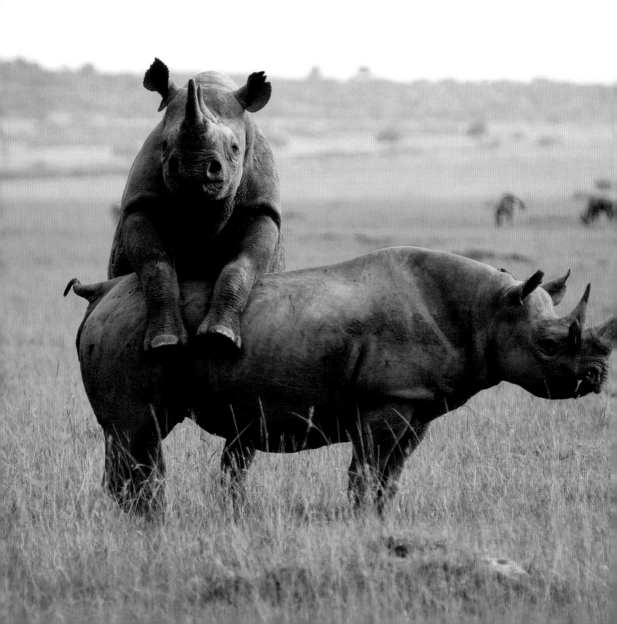

ANIMALS: Black Rhinos
LOCATION: MAASAI MARA, KENYA
The fabled L-shaped rhino. Charging around
in circles since 1983.
PHOTOGRAPHER: Adam Bannister

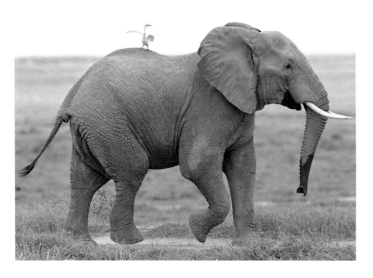

ANIMALS: Egret and Elephant
LOCATION: AMBOSELI NATIONAL PARK, KENYA
"You're going the wrong way, driver! That's the last time I order an Uber in the savannah."
PHOTOGRAPHER: Adwait Aphale

ANIMAL: Marmot
LOCATION: AUSTRIA
Sarah celebrates another narrow escape from a predator by throwing some shapes and singing 'Staying Alive'.
PHOTOGRAPHER: Martina Gebert

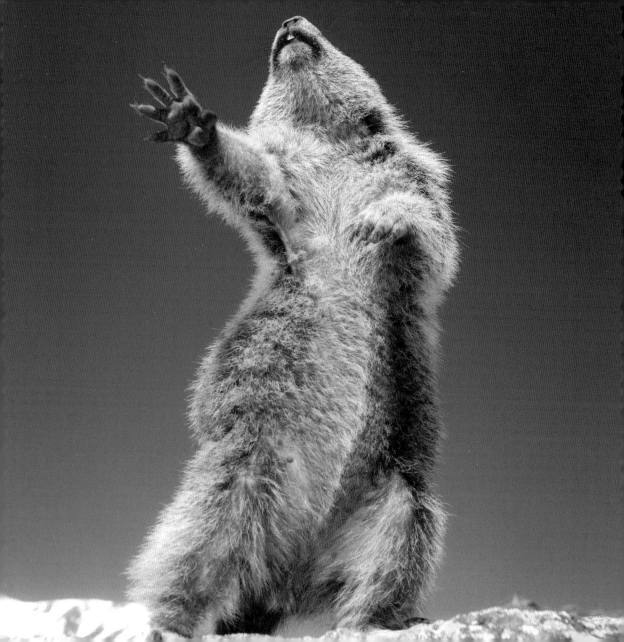

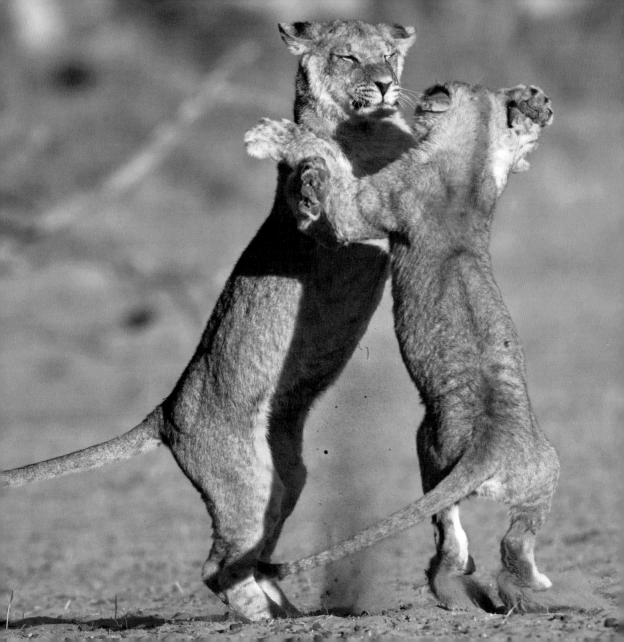

ANIMALS: Transvaal Lions

LOCATION: KGALAGADI TRANSFRONTIER PARK,
SOUTH AFRICA

From the makers of *Dances with Wolves* and *March of the Penguins* comes *Samba with Simba*.

PHOTOGRAPHER: Andrew Forsyth

ANIMALS: Burrowing Owls

LOCATION: CALIFORNIA

"When you said 'close your eyes, I've got a surprise for you', this isn't exactly what I imagined."

PHOTOGRAPHER: Ben Jiang

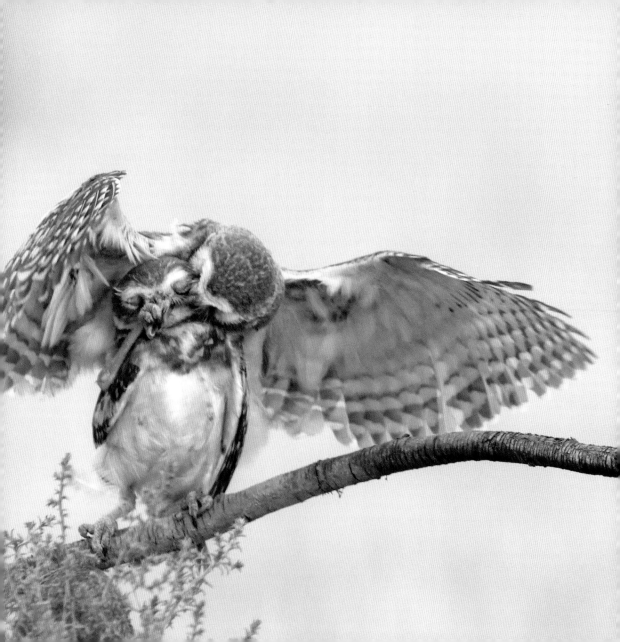

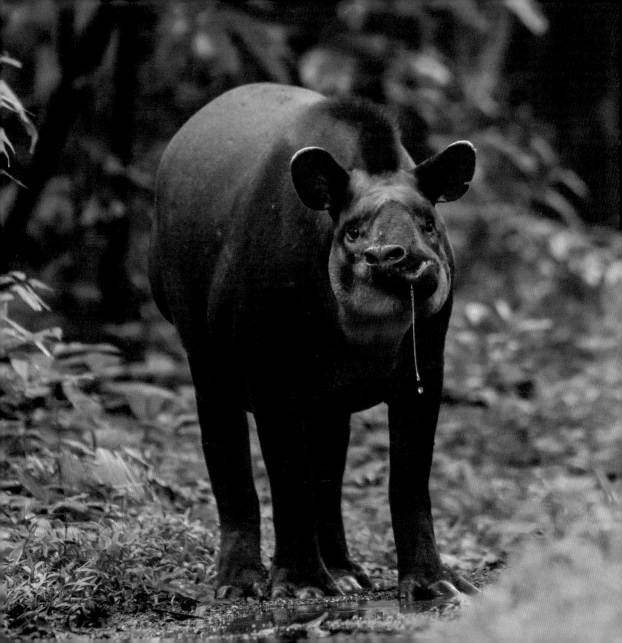

ANIMAL: Tapir

LOCATION: ECUADOR

It really is slim pickings in the jungle on Tapir Tinder.

PHOTOGRAPHER: Anton Sorokin

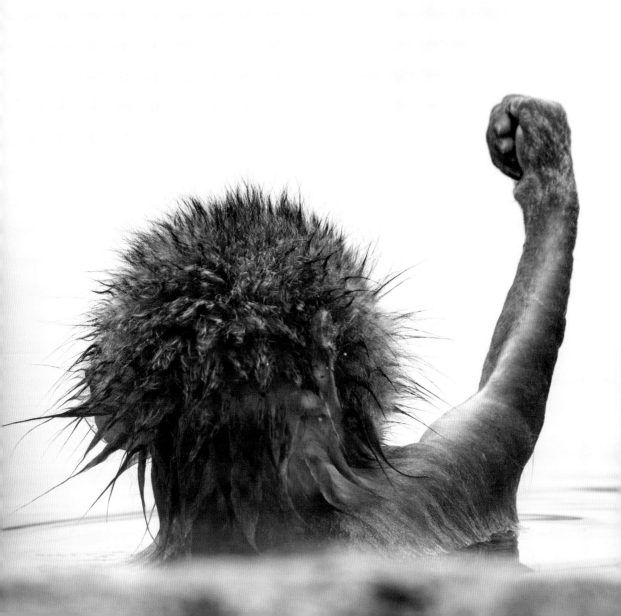

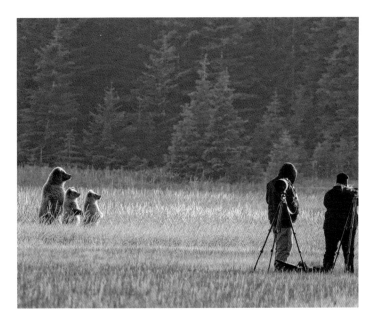

ANIMALS: Coastal Brown Bears
LOCATION: LAKE CLARK NATIONAL PARK, ALASKA
POLICE REPORT: A fugitive by the name of Goldilocks has been spotted at Paw Ridge. Vigilante justice is not recommended.
PHOTOGRAPHER: Cindy Cone

ANIMAL: Japanese Snow Monkey
LOCATION: JIGOKUDANI, NAGANO, JAPAN
One of the unused promotional posters for *Rise of the Planet of the Apes*.
PHOTOGRAPHER: Diana Rebman

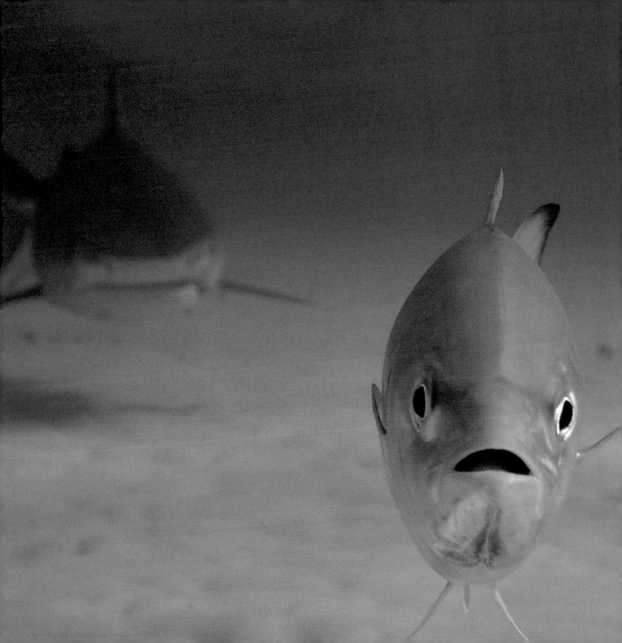

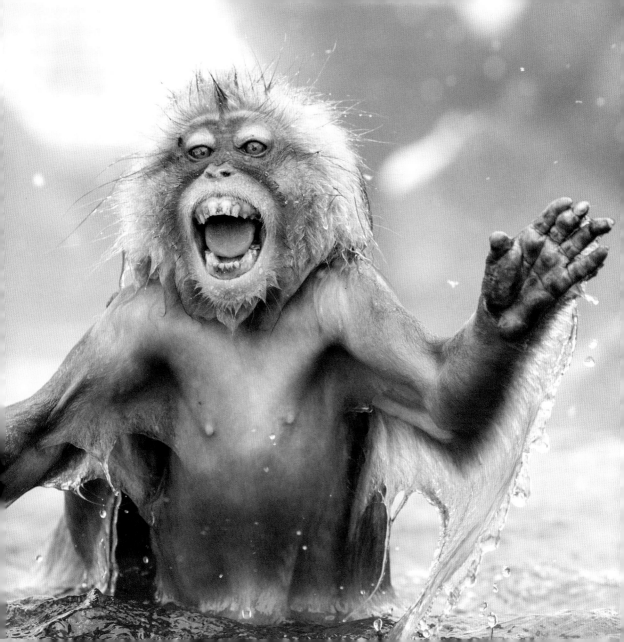

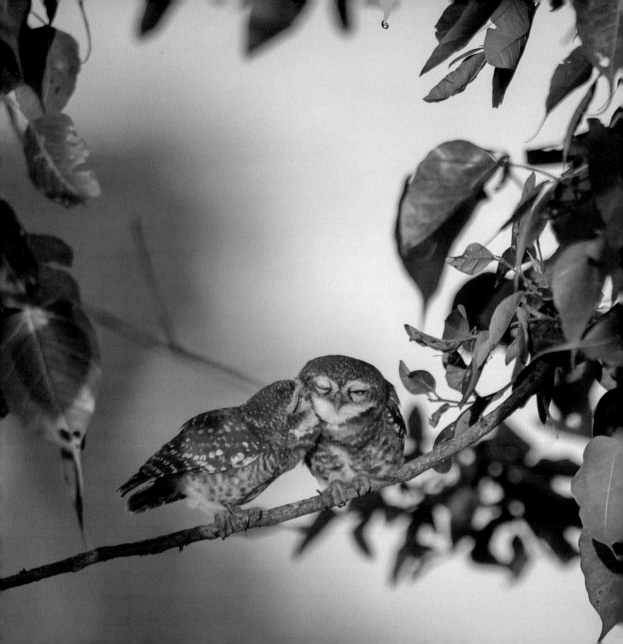

ANIMALS: Spotted Owlets

LOCATION: MADHYA PRADESH, INDIA

Possibly where the expression 'peck on the cheek' originated.

PHOTOGRAPHER: Arkaprava Ghosh

ANIMALS: Sea Otters

LOCATION: ALASKA

"What are you two up to?" "Er, my otterney tells me to plead the fifth amendment."

PHOTOGRAPHER: Donna Bourdon

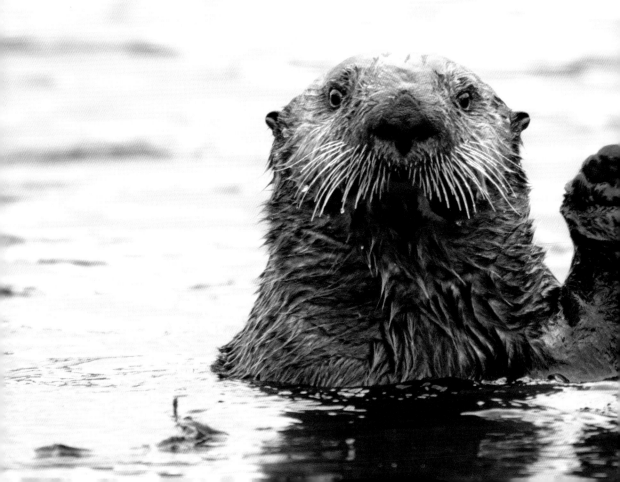

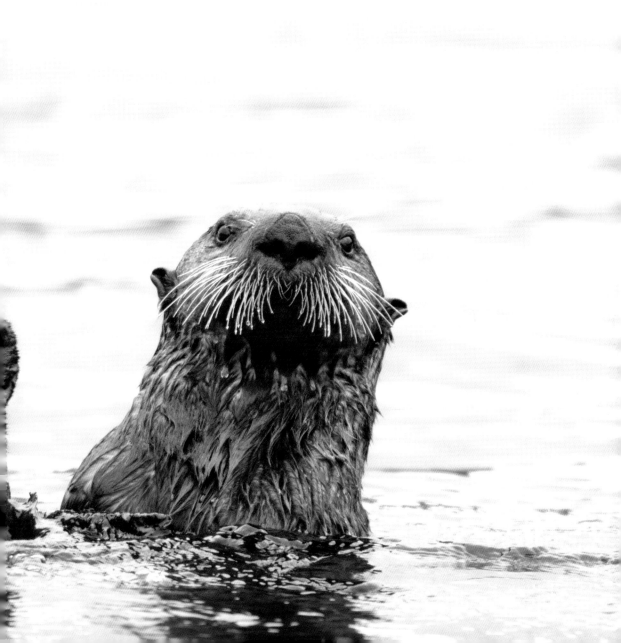

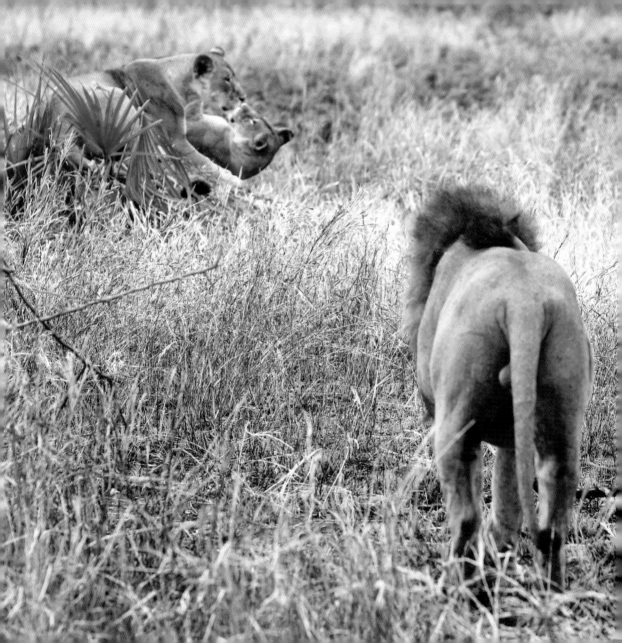

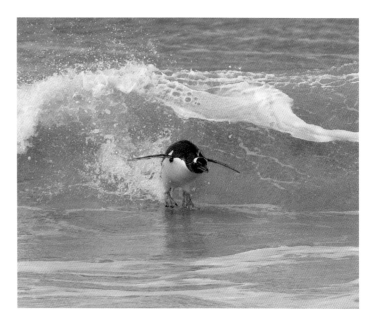

ANIMAL: Gentoo Penguin
LOCATION: BLEAKER ISLAND, FALKLAND ISLANDS
That Kelly Slater ain't so special. I don't even need a board.
PHOTOGRAPHER: Elmar Weiss

ANIMALS: Lions
LOCATION: TARANGIRE NATIONAL PARK, TANZANIA
"Nala, how could you? My pride will never recover."
PHOTOGRAPHER: Fatima Almahmoud

ANIMALS: African Elephants
LOCATION: MAASAI MARA NATIONAL RESERVE, KENYA
Glad to see the ol' wet-willy playground prank happens everywhere.
PHOTOGRAPHER: Gavin Foster

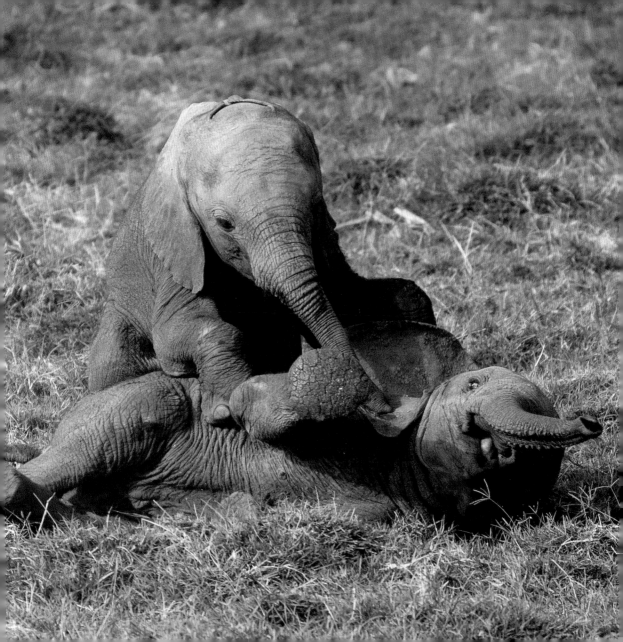

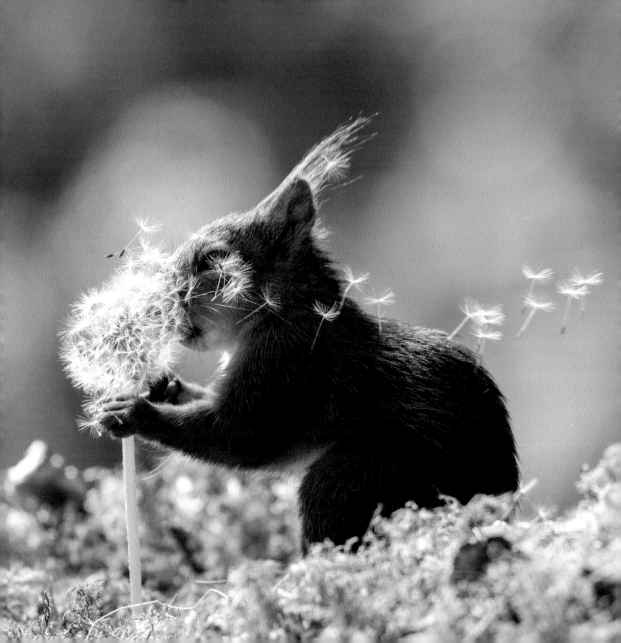

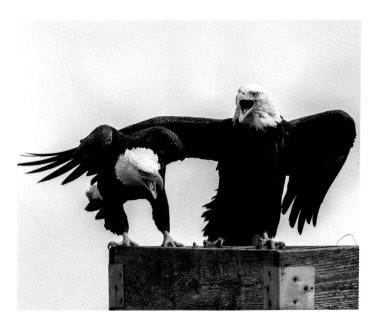

ANIMALS: Bald Eagles
LOCATION: BLACKWATER NATIONAL WILDLIFE REFUGE, MARYLAND, USA
"So you're telling me the President tried to put a little blonde wig on you for the Oval Office photoshoot?!"
PHOTOGRAPHER: George Cathcart

ANIMAL: Red Squirrel
LOCATION: SWEDEN
I wish for a peanut, a walnut, an almond, a hazelnut, an almond, a Brazil nut, a chestnut, a pecan, a pistachio, a peanut, a walnut...
PHOTOGRAPHER: Geert Weggen

ANIMAL: Grizzly Bear

LOCATION: KURIL LAKE, KAMCHATKA, RUSSIA

Unable to chomp through this odd-looking tree, Barry tries to make it fall down with his mind.

PHOTOGRAPHER: Daisy Gilardini

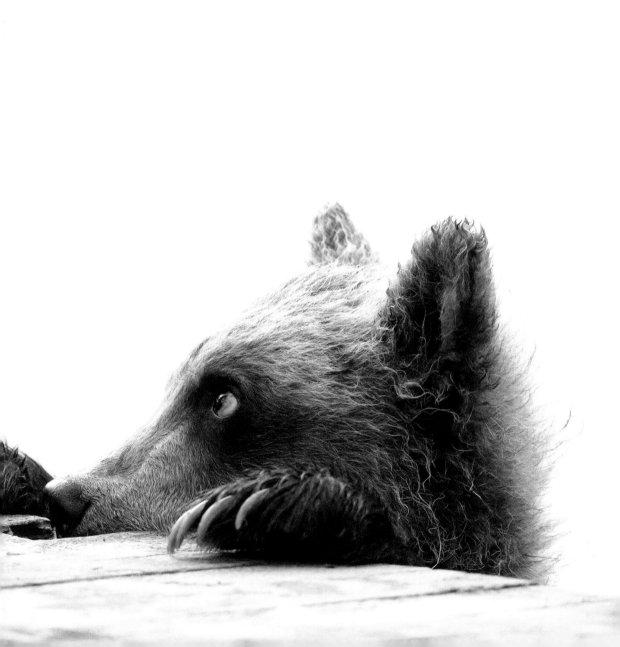

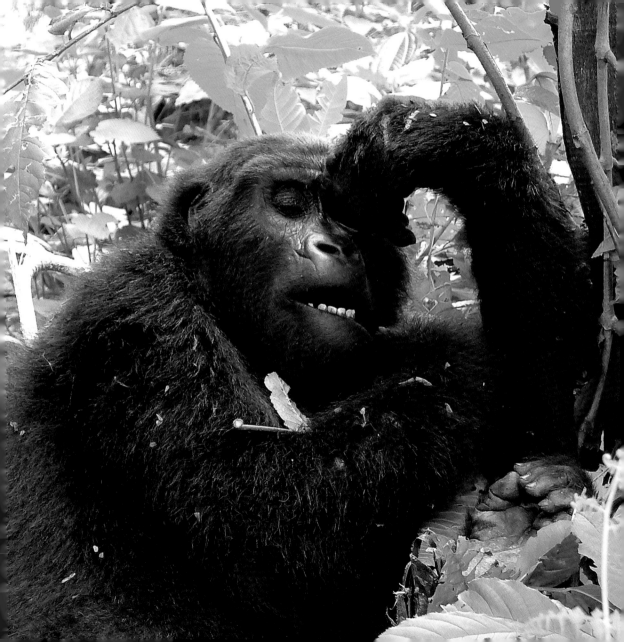

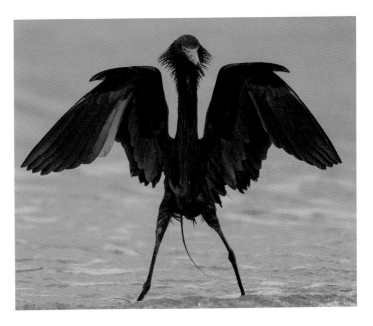

ANIMAL: Reddish Egret
LOCATION: LIDO KEY BEACH, SARASOTA, FLORIDA
John Crane: the fastest gunslinger this side of the Rio Bravo.
PHOTOGRAPHER: Gunilla Imshaug

ANIMAL: Mountain Gorilla
LOCATION: BWINDI IMPENETRABLE FOREST, UGANDA
"I've had boring days before, but I've never tried to knock myself
out with a left hook."
PHOTOGRAPHER: Ian Brookes

ANIMAL: Duckling

LOCATION: EDINBURGH

"You know, Jesus made this look easy…"

PHOTOGRAPHER: James Hopkins

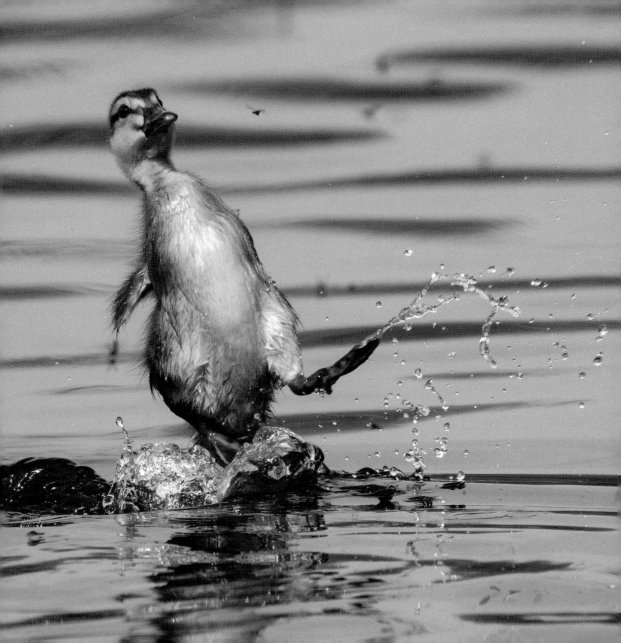

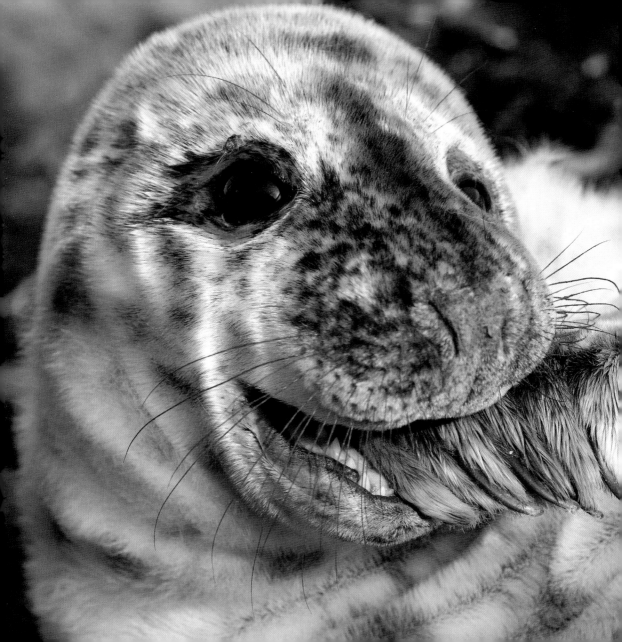

ANIMAL: Grey Seal Pup

LOCATION: GREAT SALTEE ISLAND, IRELAND
The left paw gets the seal of approval.

PHOTOGRAPHER: Jackie Campbell

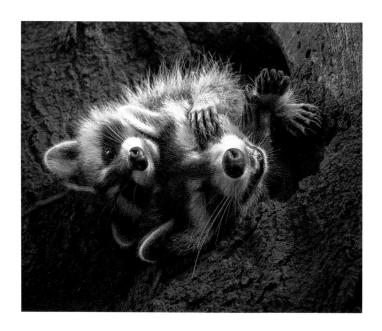

ANIMALS: Raccoons
LOCATION: WHETSTONE PARK, COLUMBUS, USA
"When I said grab onto something, maybe I should have been
more specific…"
PHOTOGRAPHER: Jayna Wallace

ANIMAL: Goshawk
LOCATION: GNESTA, SWEDEN
It's over my feathered friend. I have the high ground!
PHOTOGRAPHER: Jan Ring

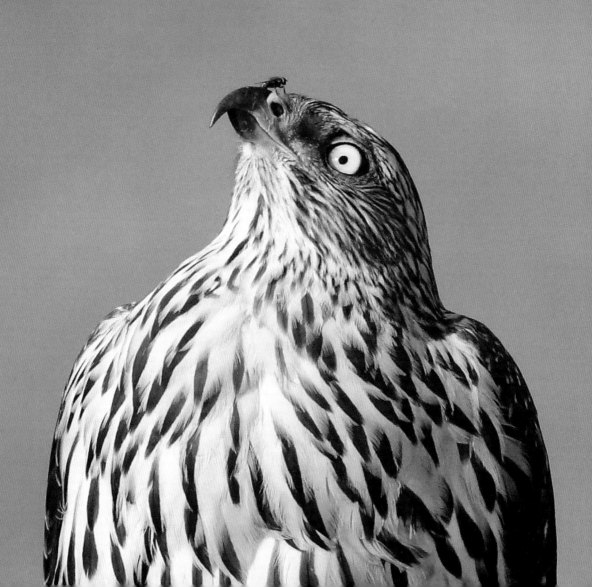

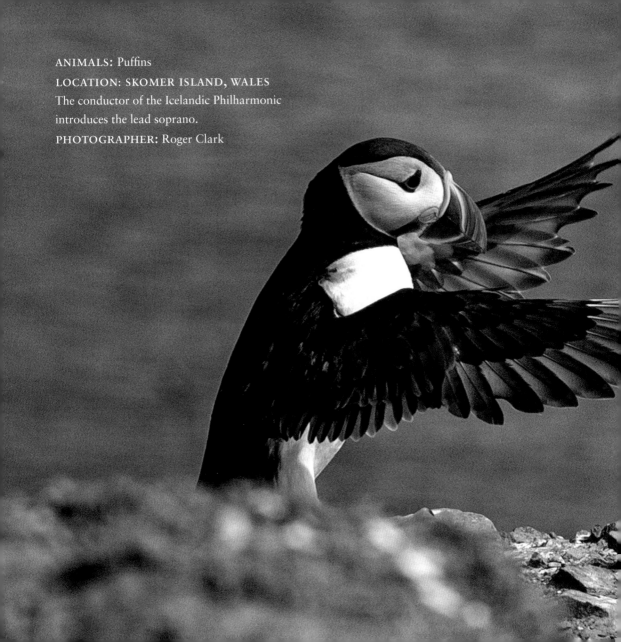

ANIMALS: Puffins
LOCATION: SKOMER ISLAND, WALES
The conductor of the Icelandic Philharmonic
introduces the lead soprano.
PHOTOGRAPHER: Roger Clark

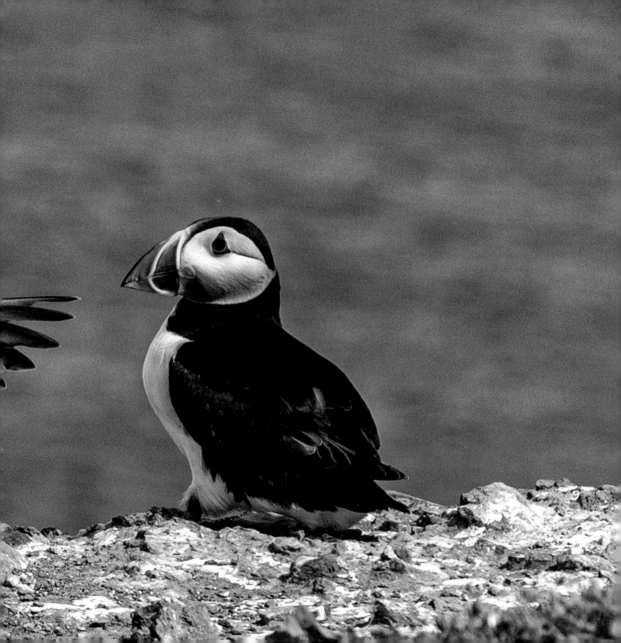

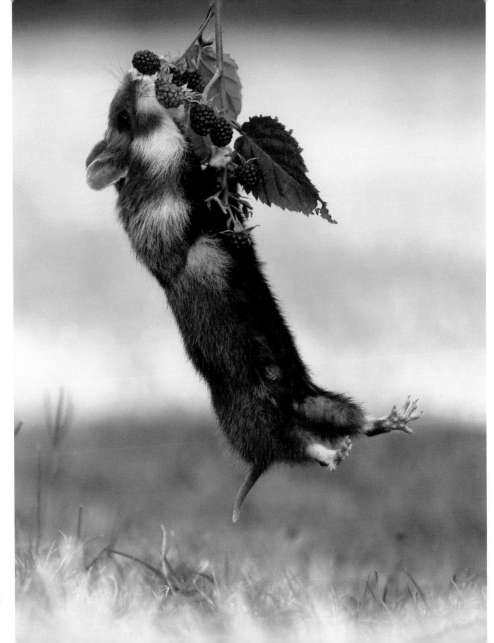

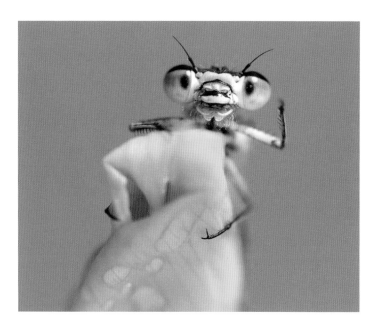

ANIMAL: Common Blue Damselfly
LOCATION: NORFOLK BROADS, UK
"Welcome to my home! You'll notice that I've gone with a soft gooseberry-coloured feature wall complemented by a uniquely climbable orange floral arrangement."
PHOTOGRAPHER: Kevin Sawford

ANIMAL: European Hamster
LOCATION: AUSTRIA
"Don't you eat that berry until you give me one more pull up!"
PHOTOGRAPHER: Julian Rad

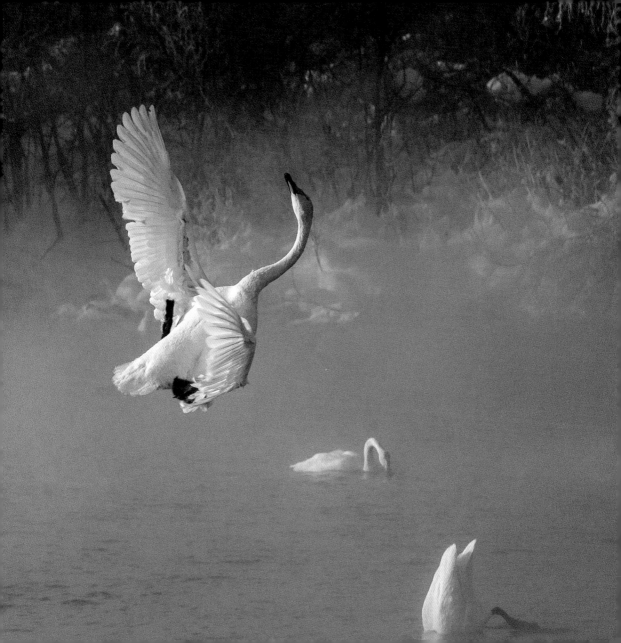

ANIMALS: Zebras

LOCATION: NGORONGORO CRATER, TANZANIA

"So I accidentally scanned myself at the self-service checkout – it turns out I'm worth 24p!"

PHOTOGRAPHER: Peter Haygarth

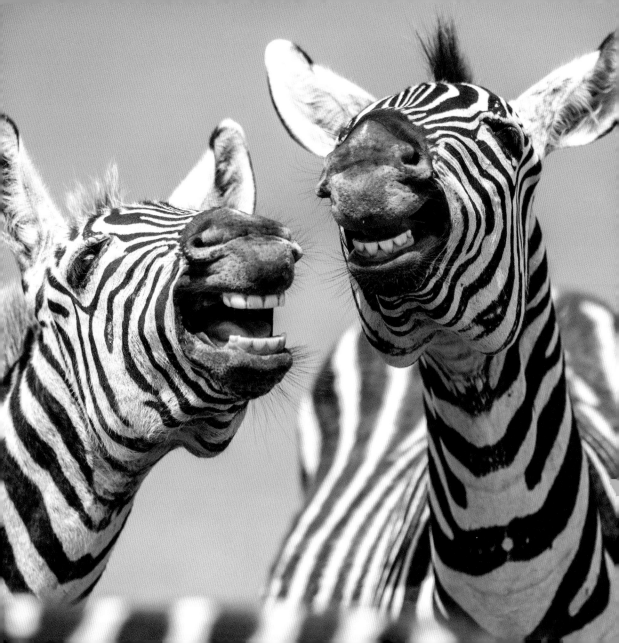

ANIMAL: Polar Bear

LOCATION: ARCTIC

Hide and seek in the Arctic does present its challenges.

PHOTOGRAPHER: Marion Vollborn

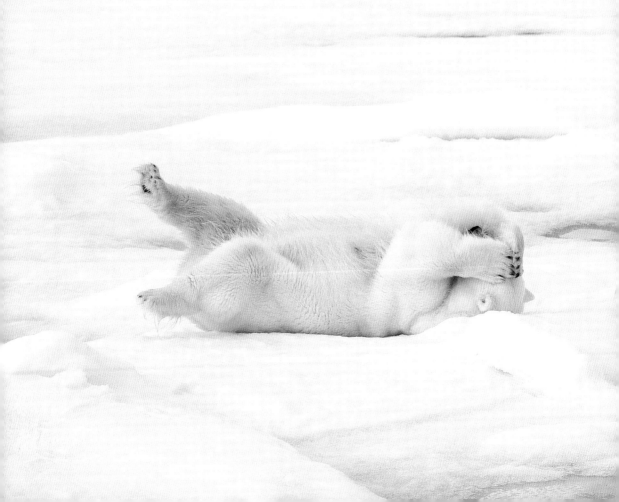

ANIMALS: Owls

LOCATION: SANTA ROSA, LA PAMPA, ARGENTINA
The Usowl Suspects.

PHOTOGRAPHER: Mario Gustavo Fiorucci

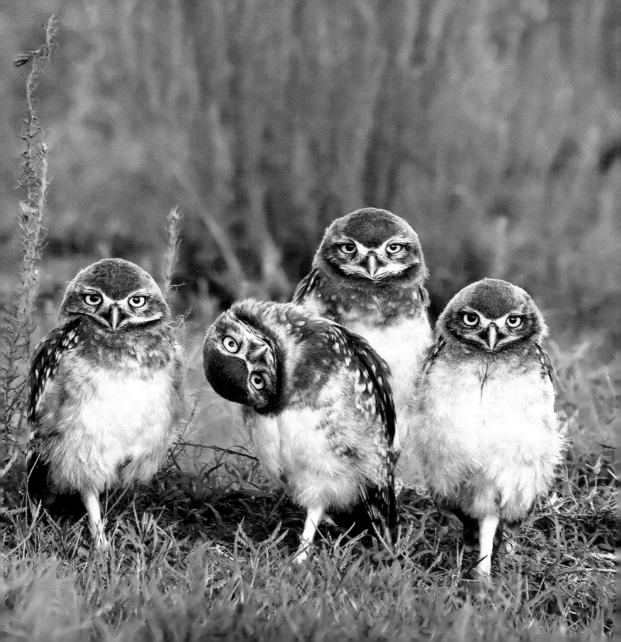

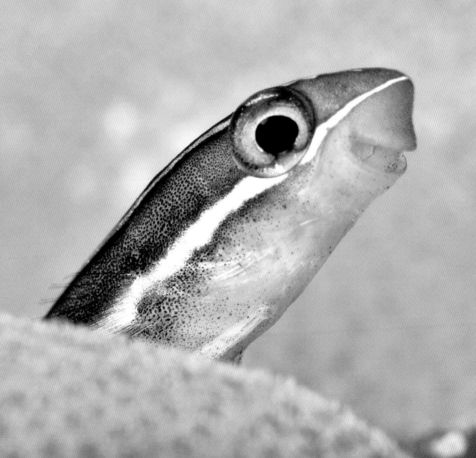

ANIMAL: Blenni

LOCATION: NEW CALEDONIA

Every morning when he heads off to work, Nemo smiles and Andrea, the anemone, waves.

PHOTOGRAPHER: Bastien Preuss

ANIMAL: Lion Cub

LOCATION: BOTSWANA

Well, Dad did always say grab life by the balls!

PHOTOGRAPHER: Sarah Skinner

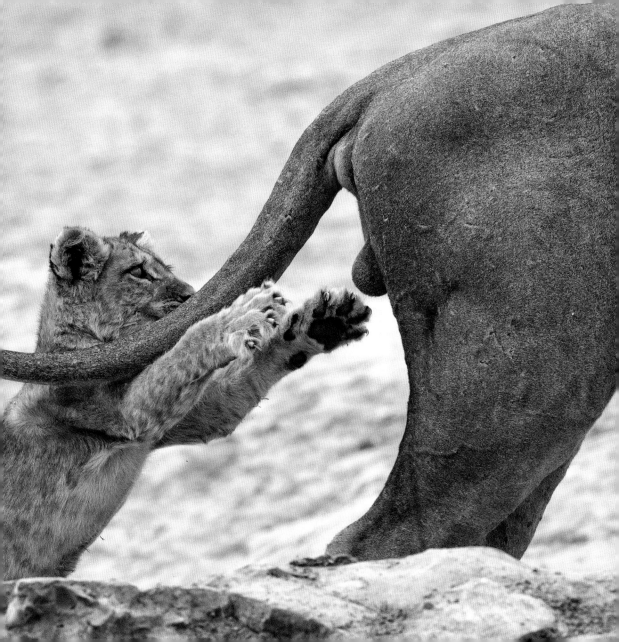

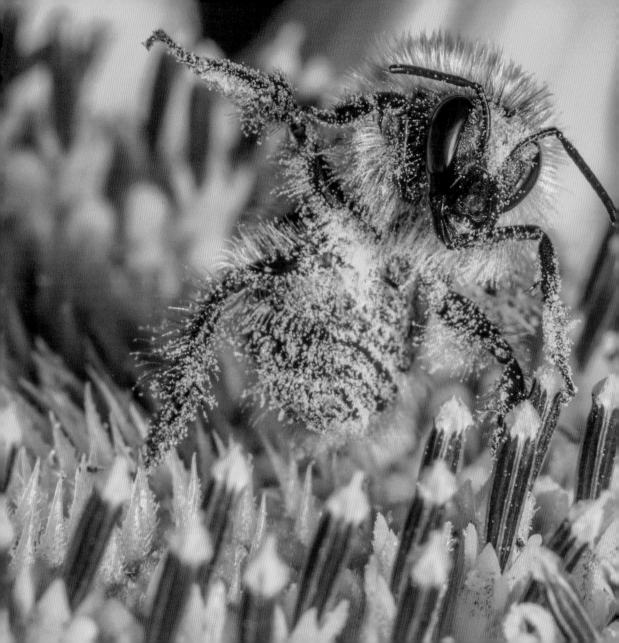

ANIMALS: Bumblebee

LOCATION: CARMARTHENSHIRE, UK

Barry came home slightly worse for wear after a night out with the Ladzzzzzzzzzz.

PHOTOGRAPHER: Steven Bailey

ANIMALS: King Penguin and Antarctic Fur Seal
LOCATION: SOUTH GEORGIA ISLAND
That awkward moment when you go in for a hug and your friend opts for the chest bump…
PHOTOGRAPHER: Thomas Mangelsen

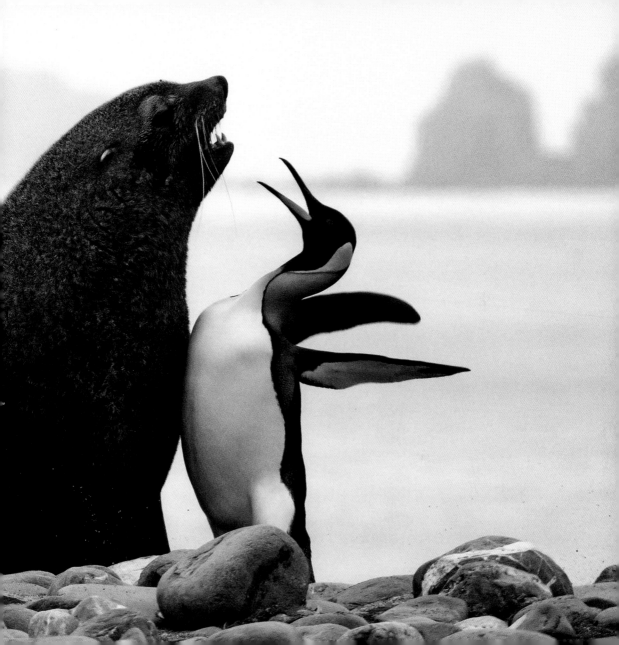

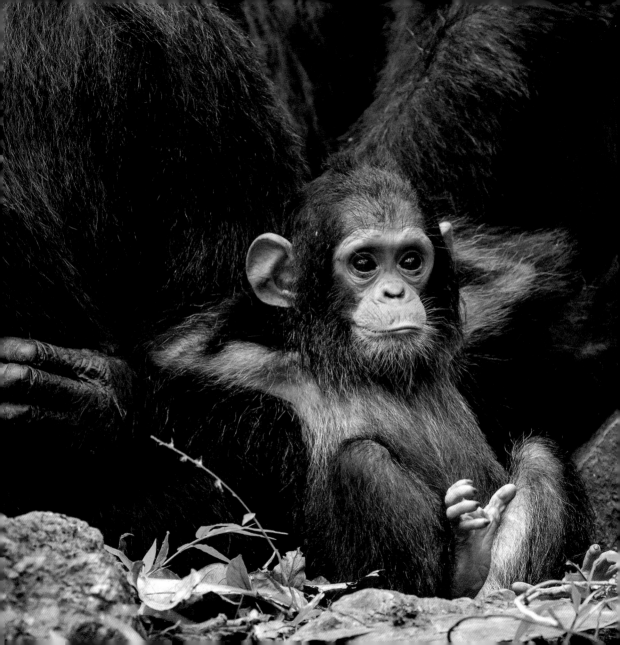

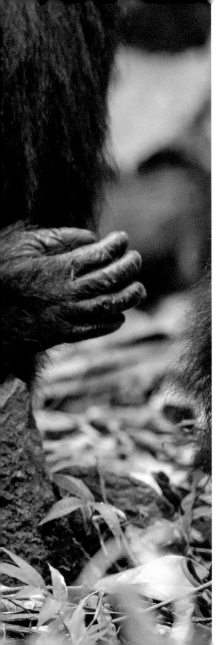

ANIMAL: Chimpanzee

LOCATION: GOMBE STREAM NATIONAL PARK, TANZANIA

After a hard day's monkeying about, sometimes you've just gotta kick back and relax.

PHOTOGRAPHER: Thomas Mangelsen

ANIMALS: White Rhino and Egret

LOCATION: NAIROBI NATIONAL PARK, KENYA

"I've watched the rains come down in Africa" has a completely different meaning to me now.

PHOTOGRAPHER: Tilakraj Nagaraj

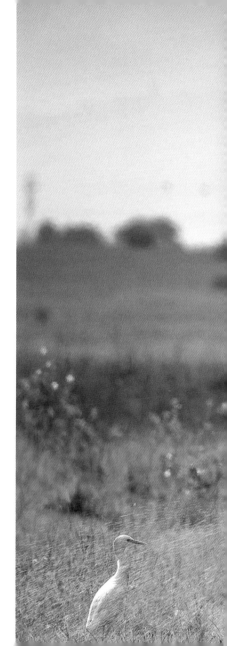

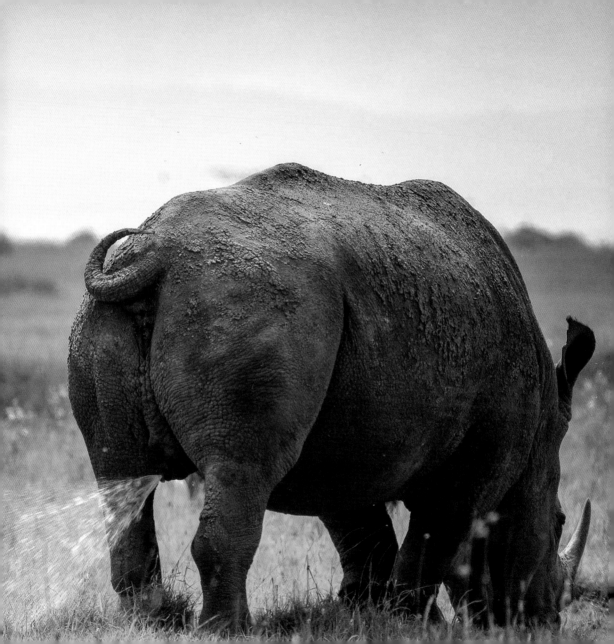

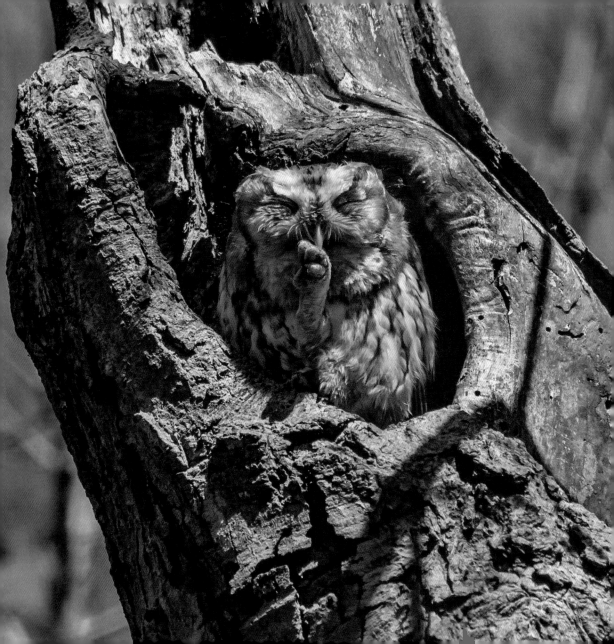

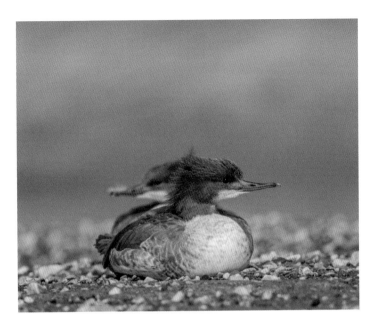

ANIMALS: Mergansers
LOCATION: WEST BENGAL
Roger was getting a lot of job offers for the position of tennis umpire.
PHOTOGRAPHER: Sudipta Chakraborty

ANIMAL: Eastern Screech Owl
LOCATION: MASSAPEQUA PARK, NEW YORK
"Hoots mon – there's a moose loose about this house."
Gets me every time.
PHOTOGRAPHER: Ruan Ke Qiang

ANIMALS: Lion

LOCATION: KGALAGADI TRANSFRONTIER PARK, SOUTH AFRICA

If I just turn this a little bit, dinner will be delivered straight to our door.

PHOTOGRAPHER: Willem Kruger

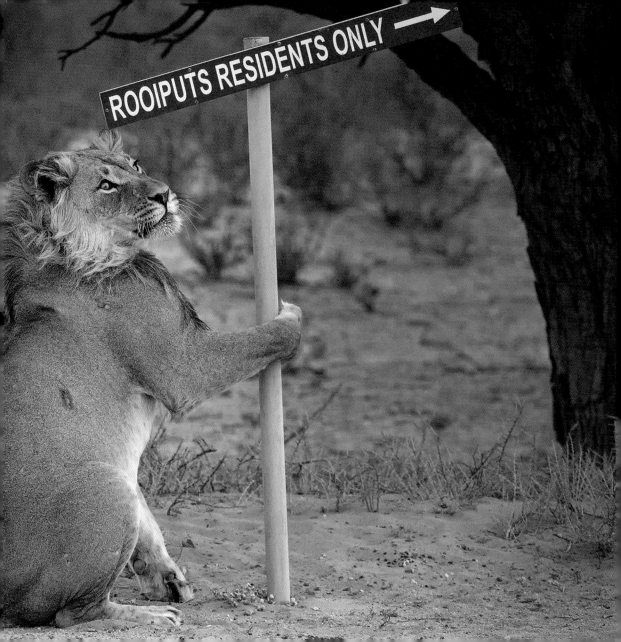

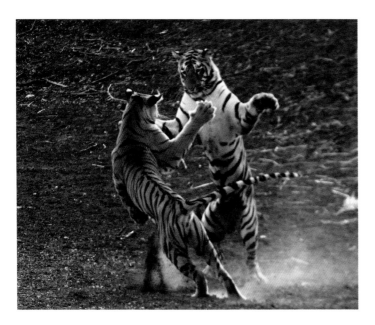

ANIMALS: Tigers

LOCATION: TADOBA

"Only one of us can be the face of Frosties!"

PHOTOGRAPHER: Vishwanath Madham

ANIMALS: Snow Monkey

LOCATION: JAPAN

To be or not to be, that is the question...

PHOTOGRAPHER: Txema Garcia Laseca

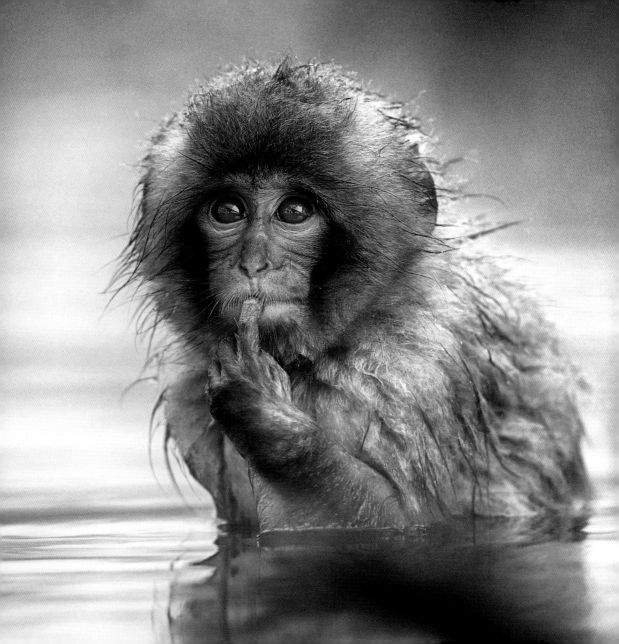

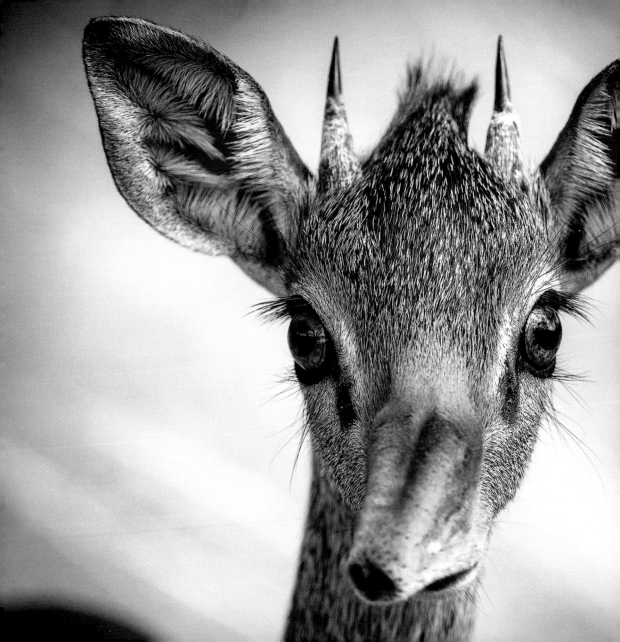

ANIMAL: Dik Dik

LOCATION: SAMBURU, KENYA

Every time I tell a lie, my nose grows another inch. Or is it two inches? Oh no, I've done it again!

PHOTOGRAPHER: Yaron Schmid

ANIMALS: Red Foxes
LOCATION: AMSTERDAM, HOLLAND
They've certainly spiced the Foxtrot up a bit since the early 20th century.
PHOTOGRAPHER: Alastair Marsh

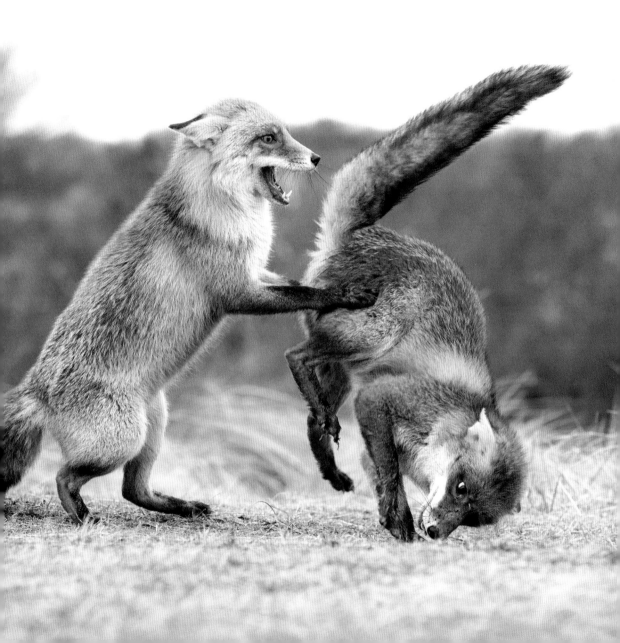

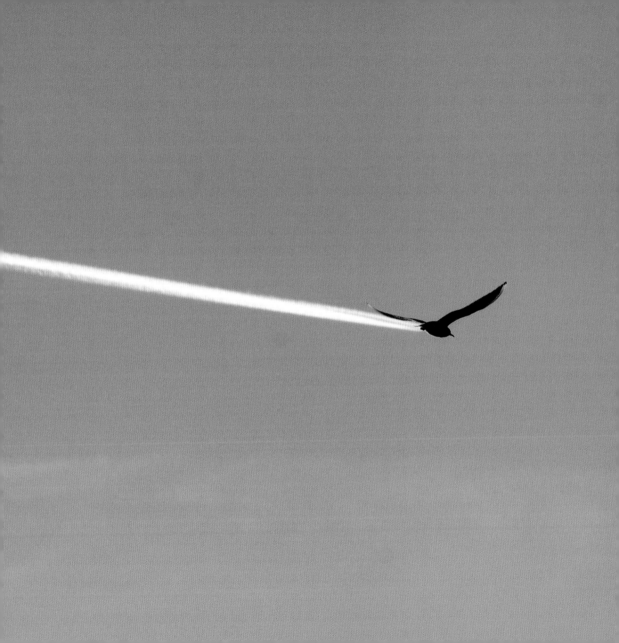

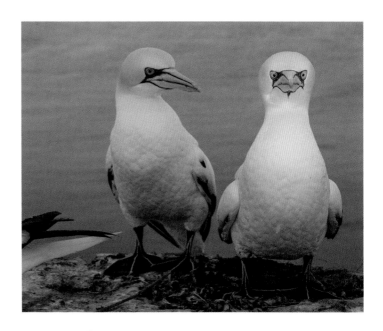

ANIMALS: Gannets
LOCATION: HELGOLAND, GERMANY
I know gannets will eat anything, but a lightbulb is a step too far.
PHOTOGRAPHER: Co Grift

ANIMAL: Gull
LOCATION: HULL, EAST YORKSHIRE
Finally we learn how seagulls are able to quickly steal your chips
while your head is turned – they're rocket-powered.
PHOTOGRAPHER: Bob Carter

ANIMALS: Gentoo Penguins

LOCATION: SOUTH GEORGIA

The gentoo penguin tai chi class is really taking off
on the Falkland Islands.

PHOTOGRAPHER: Andre Erlich

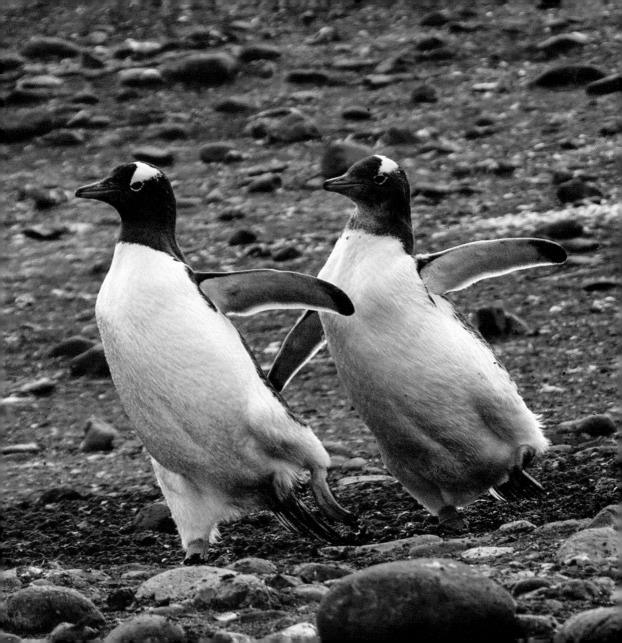

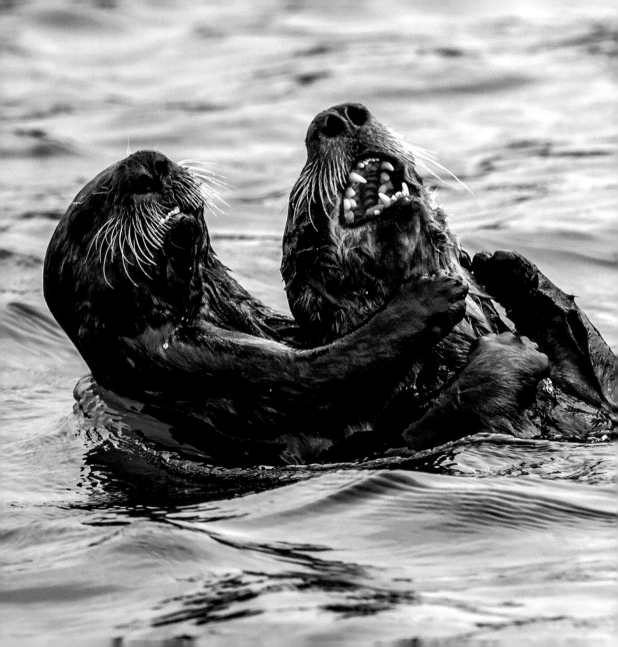

ANIMALS: Sea Otters

LOCATION: ELKHORN SLOUGH, CALIFORNIA, USA
That's not how I remember the life-saving class at school.

PHOTOGRAPHER: Andy Harris

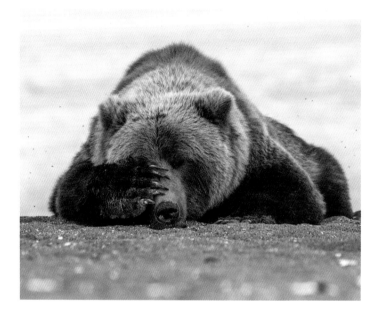

ANIMAL: Brown Bear
LOCATION: ALASKA
Oh no, it's Monday morning again.
PHOTOGRAPHER: Eric Fisher

ANIMAL: Fox Squirrel
LOCATION: UNIVERSITY OF MICHIGAN, ANN ARBOR, MICHIGAN, USA
The rarely seen Michigan Squirrel eating oak.
PHOTOGRAPHER: Corey Seeman

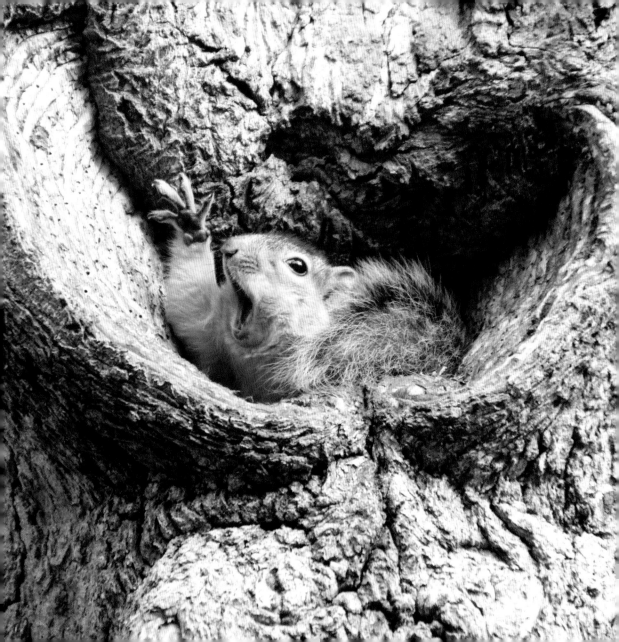

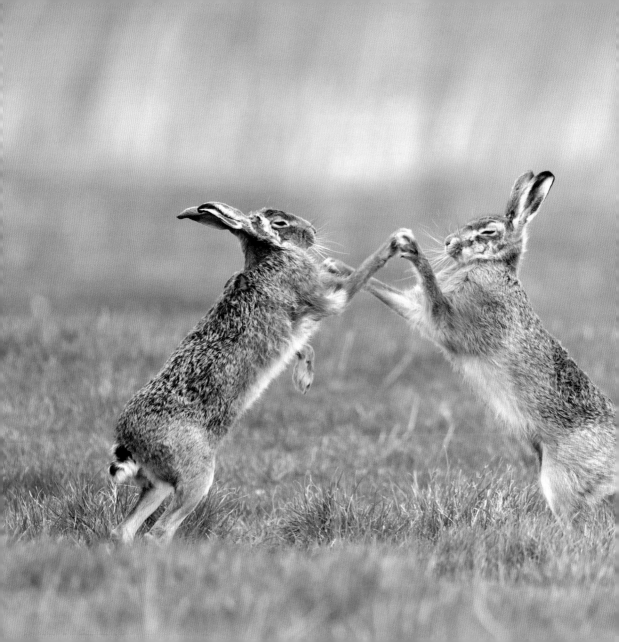

ANIMALS: Brown Hares
LOCATION: SUFFOLK, UK
And here we can see Melinda (on the right) teaching her not-quite-getting-it husband the original 'Lindy Hop' dance.
PHOTOGRAPHER: Philip Marazzi

First date.

Wedding day first dance.

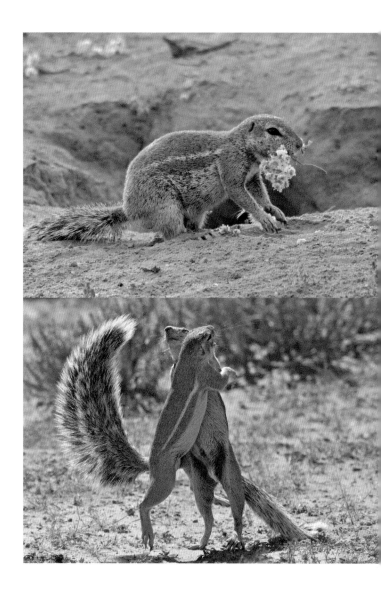

ANIMALS: Cape Squirrels
LOCATION: KALAHARI,
SOUTH AFRICA
PHOTOGRAPHER: Elaine Kruer

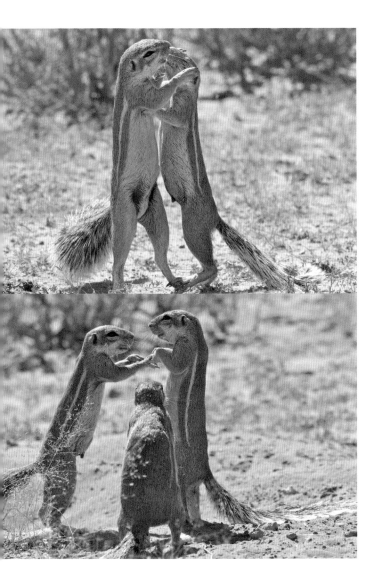

First kiss.

Baby's first birthday.

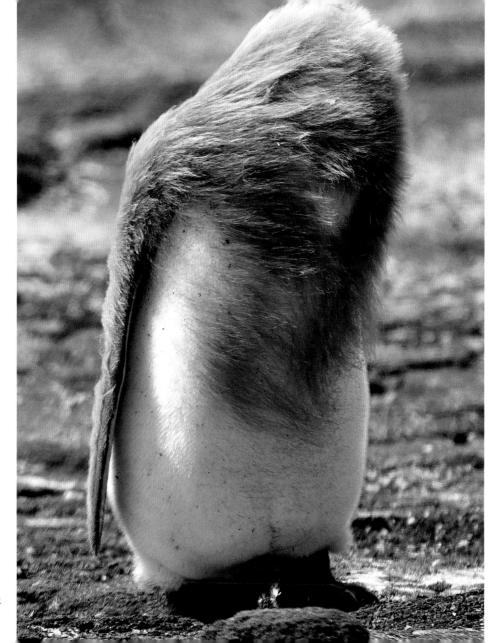

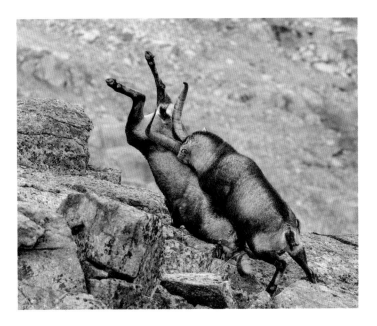

ANIMALS: Iberian Wild Goats

LOCATION: SIERRA DE GREDOS, SPAIN

Ever wondered about the origin of the word 'headbutt'? Look no further.

PHOTOGRAPHER: George Dian Balan

ANIMAL: King Penguin

LOCATION: SOUTH GEORGIA ISLAND

Well, that's the last time I ask for a blow dry after the cut.

PHOTOGRAPHER: Eric Keller

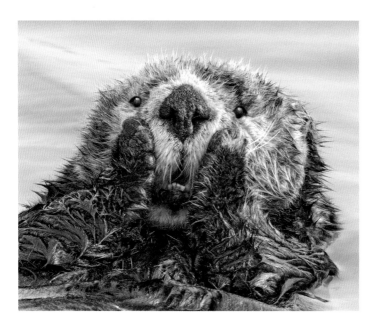

ANIMAL: Sea Otter
LOCATION: SMALL BOAT HARBOR, SEWARD, ALASKA
Hang on, that's not moisturizer, it's superglue!
PHOTOGRAPHER: Harry Walker

ANIMAL: King Penguin
LOCATION: SOUTH GEORGIA ISLAND
Sneaky rear gun salute.
PHOTOGRAPHER: Eric Keller

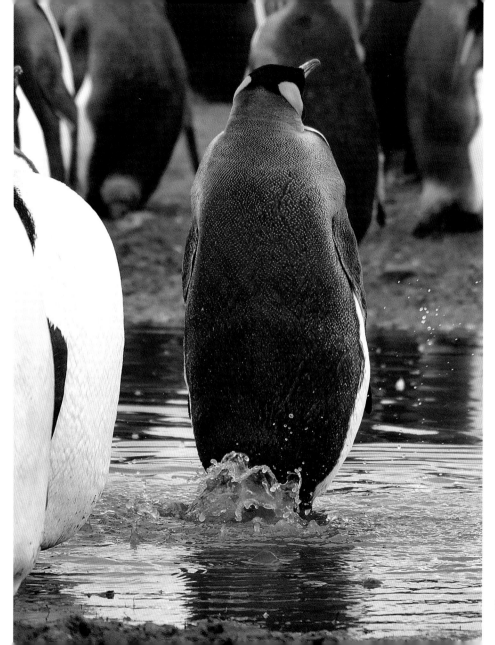

ANIMALS: Grey Seal

LOCATION: FAR NORTH OF SCOTLAND
"Just a whisker trim today, please barber."
PHOTOGRAPHER: Ken Crossan

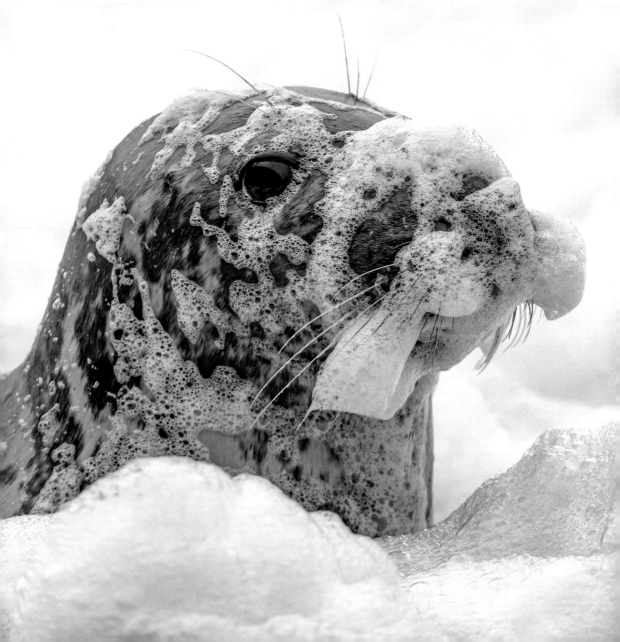

Stratford-Upon-Avon's Swan Theatre lives up to its name with a new season of Shakespeare plays.

"A pair of star-cross'd lovers." (Romeo and Juliet)

"A hit, a very palpable hit." (Hamlet)

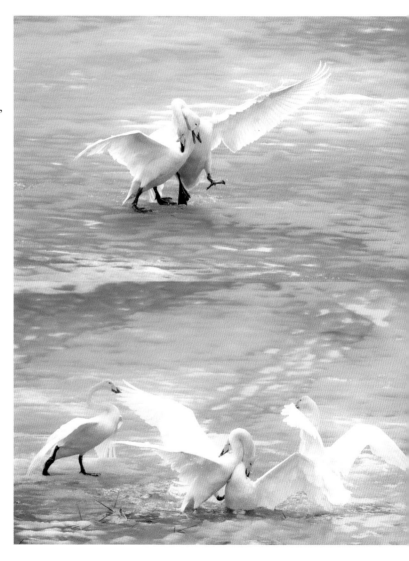

ANIMALS: Whooper Swans
LOCATION: PIRKANMAA, FINLAND
PHOTOGRAPHER: Esa Ringbom

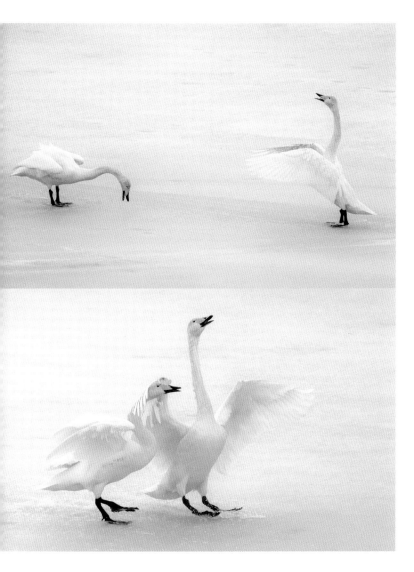

"All hail, Macbeth, thou shalt be king hereafter!" (Macbeth)

"We few, we happy few, we band of brothers." (Henry V)

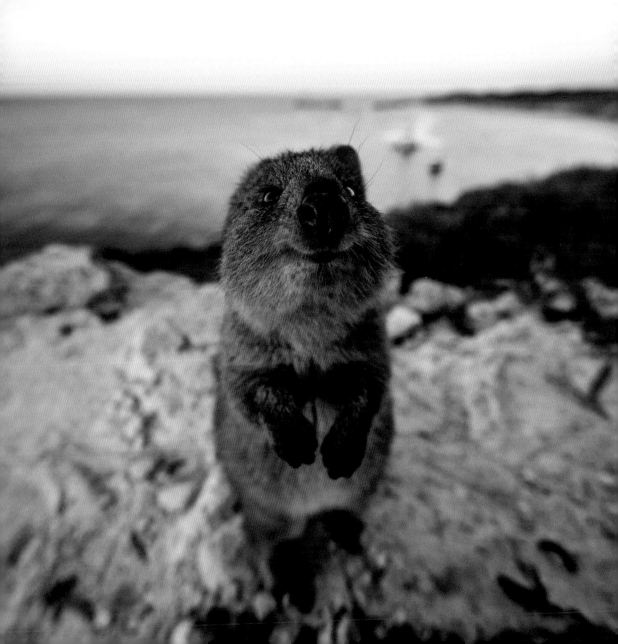

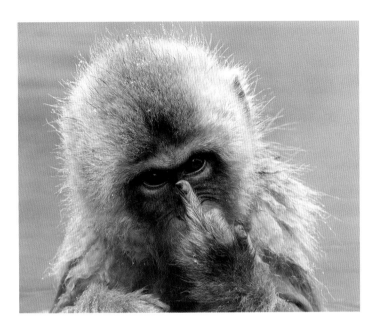

ANIMAL: Snow Macaque

LOCATION: JAPAN

Well, what do you expect when you take a nude photo of someone in the bath without their permission?

PHOTOGRAPHER: Jari-Peltomäki

ANIMAL: Quokka

LOCATION: ROTTNEST ISLAND, AUSTRALIA

"Please sir, can I have some more?"

PHOTOGRAPHER: James Vodicka

ANIMALS: King Penguins

LOCATION: SALISBURY PLAIN, SOUTH GEORGIA, SOUTH ATLANTIC

"You should see the other guy."

PHOTOGRAPHER: Linda Martin

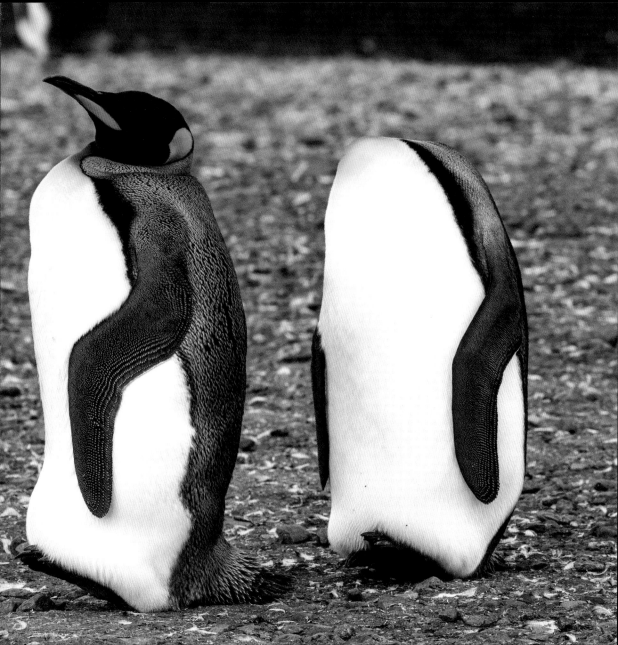

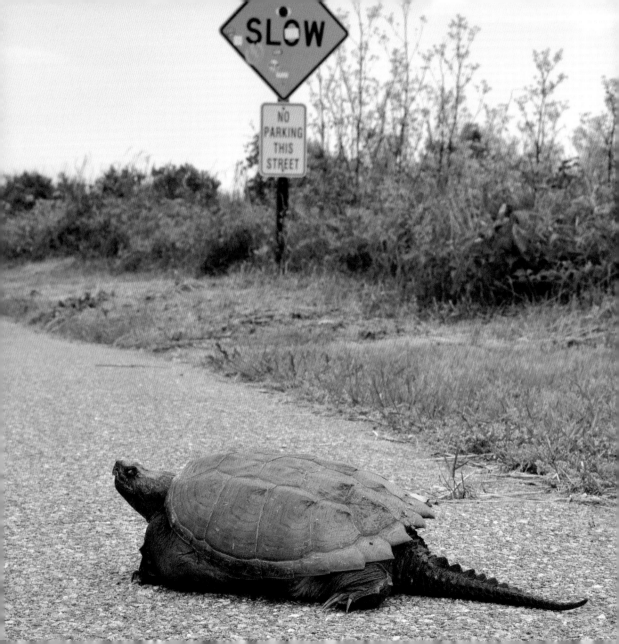

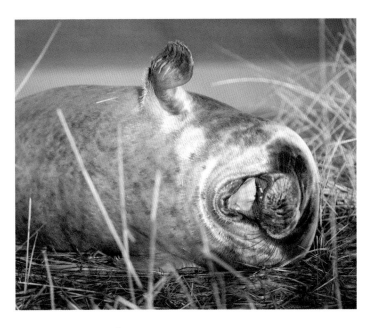

ANIMAL: Grey Seal

LOCATION: DONNA NOOK

"Seal you later – what a classic."

PHOTOGRAPHER: Lloyd Durham

ANIMAL: Snapping Turtle

LOCATION: MASSACHUSETTS

The slow sign puts a dent in Mavis trying out her new
turbo boosters.

PHOTOGRAPHER: Lisa Vanderhoop

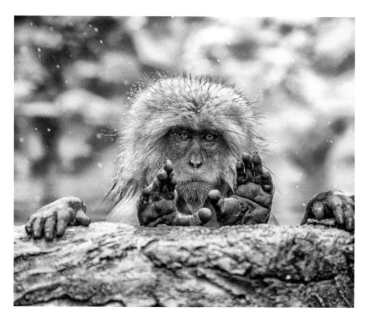

ANIMAL: Japanese Macaque
LOCATION: JIGOKUDANI MONKEY PARK
His hands say I'm innocent, but with a face that colour, you're always going to look like you've done something wrong.
PHOTOGRAPHER: Pablo-Daniel Fernández

ANIMALS: Lioness
LOCATION: MAASAI MARA, KENYA
"What do you mean you've gone vegetarian?!"
PHOTOGRAPHER: Adwait Aphale

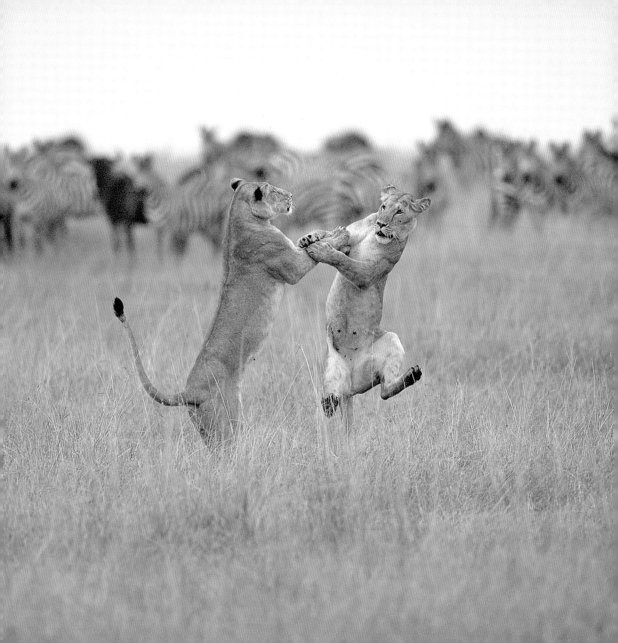

ANIMALS: Northern Crested Caracara and Capybara
LOCATION: RINCON DEL SOCORRO, IBERA
WETLANDS, ARGENTINA
The revenue protection officer brought some hefty
bailiffs with her this time.
PHOTOGRAPHER: Susan Knowler

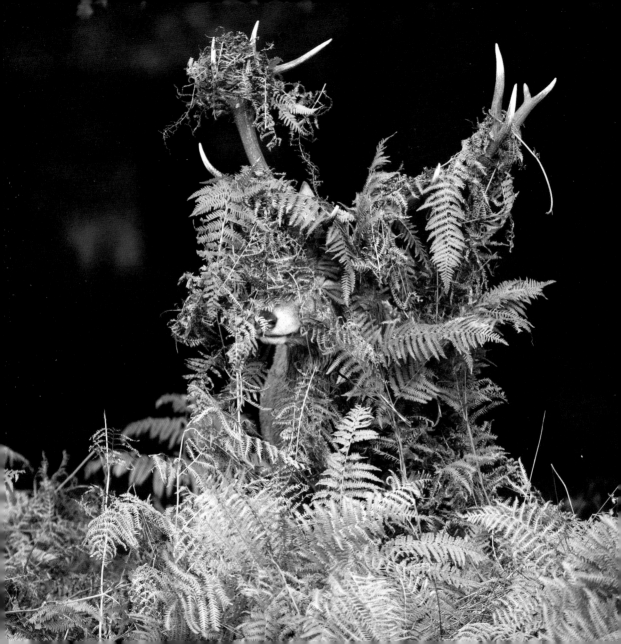

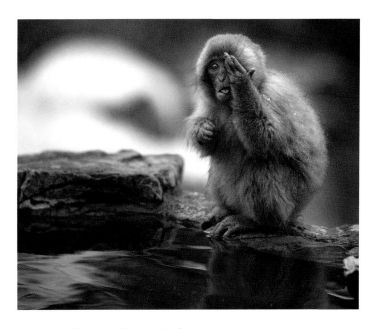

ANIMAL: Japanese Snow Monkey
LOCATION: JAPAN
Abu's eye test really wasn't going that well.
PHOTOGRAPHER: Roie Galitz

ANIMAL: Red Deer
LOCATION: RICHMOND PARK
Grown-up Bambi goes to great lengths to avoid the tourists in
Richmond Park.
PHOTOGRAPHER: Mike Rowe

"Er, this is my tree! See the hole here – I pecked that."

"Also my tree. Do you know how long I spent carving out that v-shaped channel in the top? Craftsmanship that is."

ANIMAL: Little Owl Fledging and Great Spotted Woodpecker
LOCATION: PIRKANMAA
PHOTOGRAPHER: Philip Winter

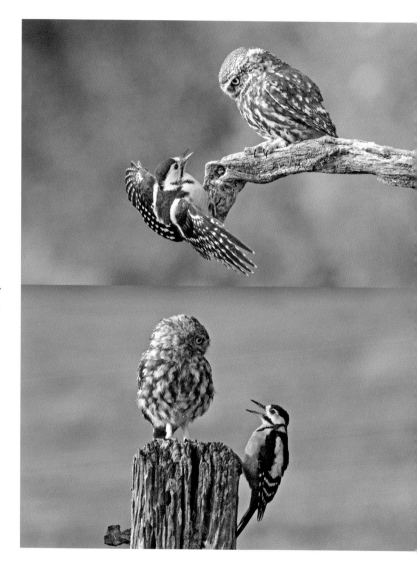

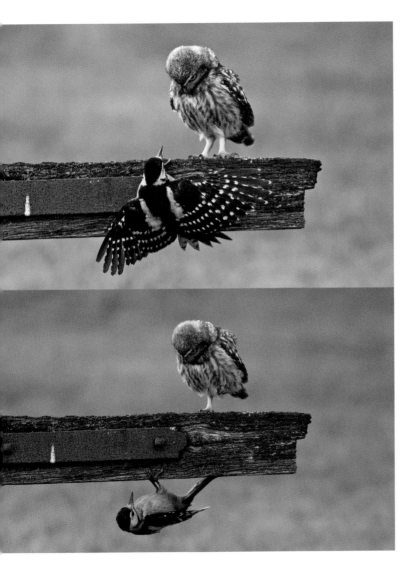

"Really sorry to be a pain but this one's also mine. See, they even put an iron bar on to stop me pecking it!"

"Fine, I'll compromise. Now only half of me is on the tree. Ok?'

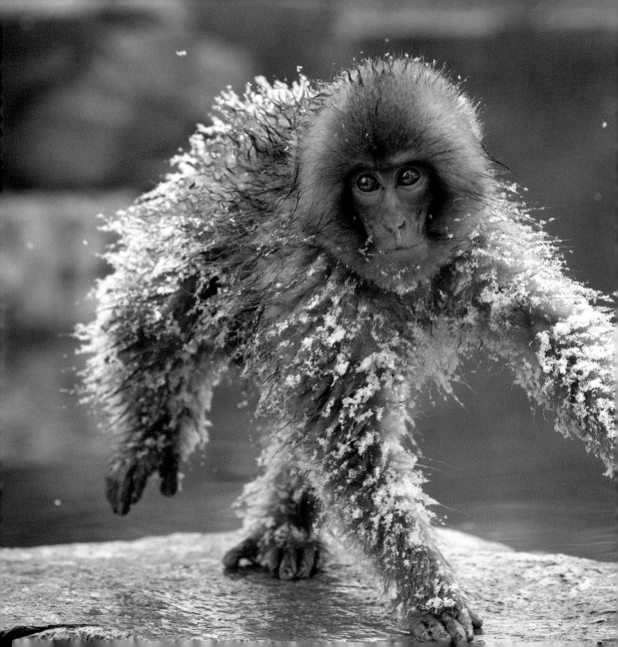

ANIMAL: Japanese Snow Monkey

LOCATION: JAPAN

Due to budgetary restrictions, the Apollo programme cut a few corners on their space suits for their monkey astronauts.

PHOTOGRAPHER: Roie Galitz

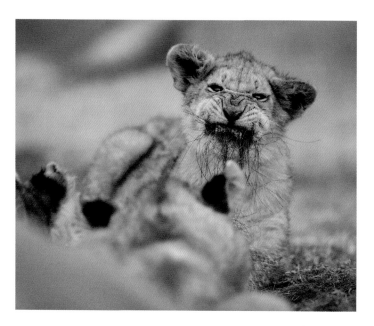

ANIMAL: Lion Cub
LOCATION: MAASAI MARA KENYA
"Son, you're not supposed to eat the hairy bits!"
PHOTOGRAPHER: Trai Anfield

ANIMALS: Chimpanzee
LOCATION: NGAMBA ISLAND CHIMPANZEE SANCTUARY,
UGANDA
"Pass me the ball – I'm wide open!"
PHOTOGRAPHER: Ryan Jefferds

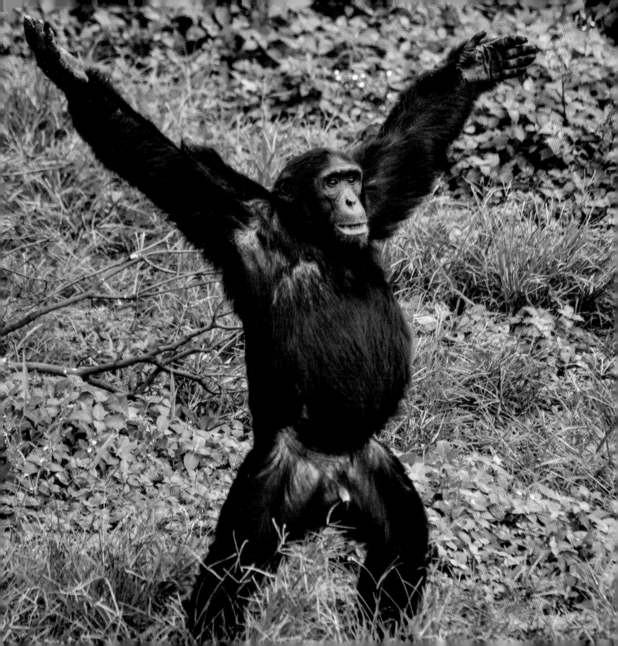

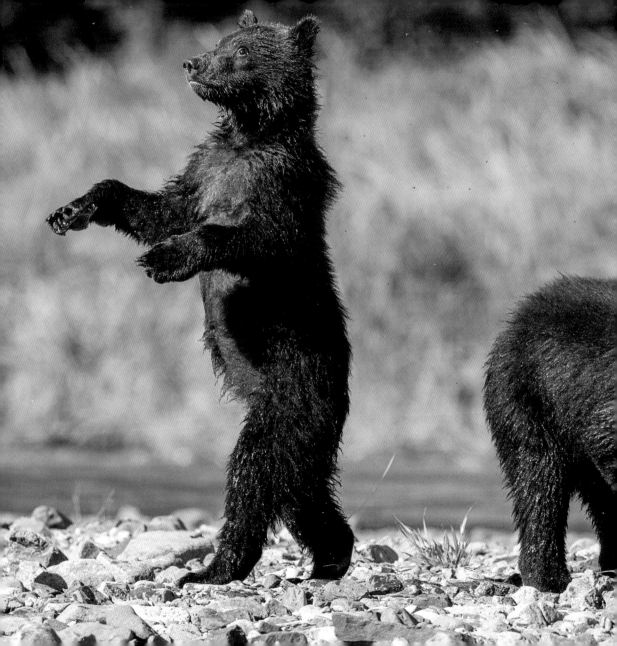

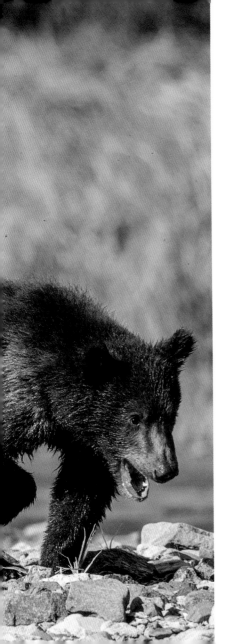

ANIMALS: Grizzly Bears

LOCATION: KODIAK ISLAND ALASKA

"Dude, your zombie impression is unbearable."

PHOTOGRAPHER: Toni Elliott

ANIMALS: Snowy Owl
LOCATION: JONES BEACH, LONG ISLAND
The Hedwig blooper reel is worth a watch.
PHOTOGRAPHER: Vicki Jauron

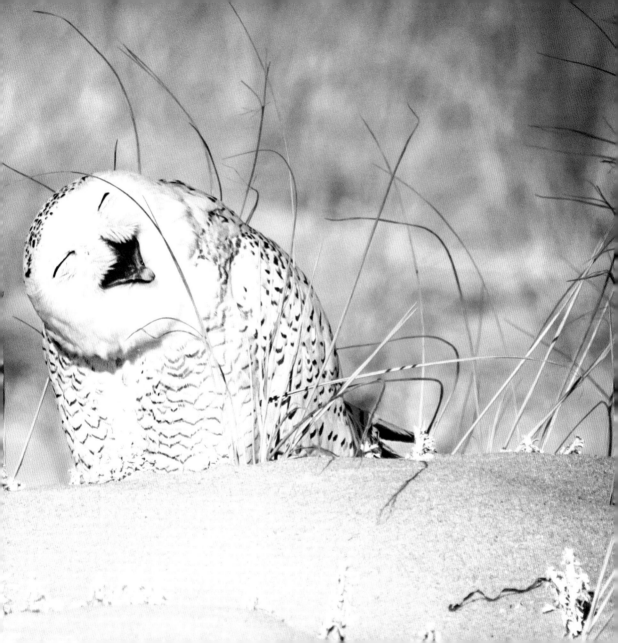

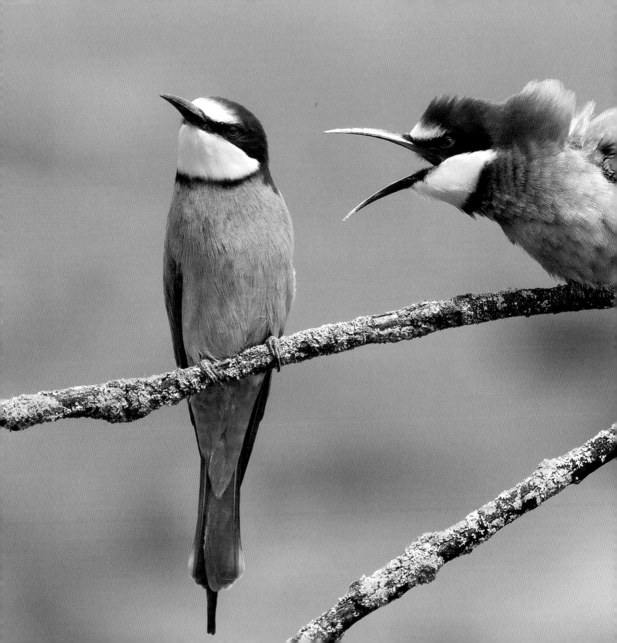

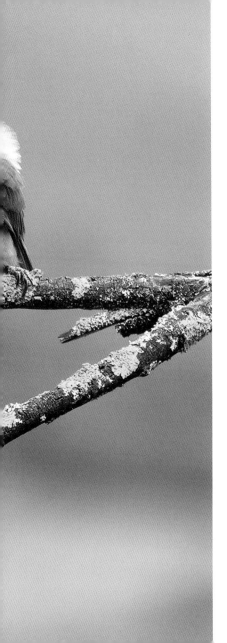

ANIMALS: European Bee-Eater
LOCATION: CROATIA
"How dare you tell me I'm having a bad hair day!"
PHOTOGRAPHER: Vlado Pirsa

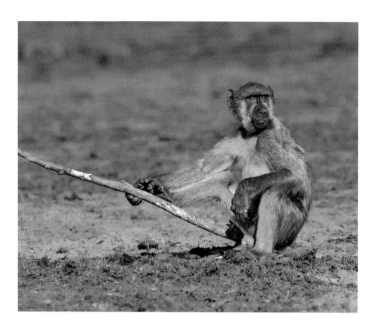

ANIMAL: Baboon
LOCATION: KGALAGADI TRANSFRONTIER PARK,
SOUTH AFRICA
This baboon is really missing the fishing trip he took last year.
PHOTOGRAPHER: Willem Kruger

ANIMAL: Raccoon
LOCATION: SANDSTONE, MINNESOTA, USA
Two back doors.
PHOTOGRAPHER: Wendy Kaveney

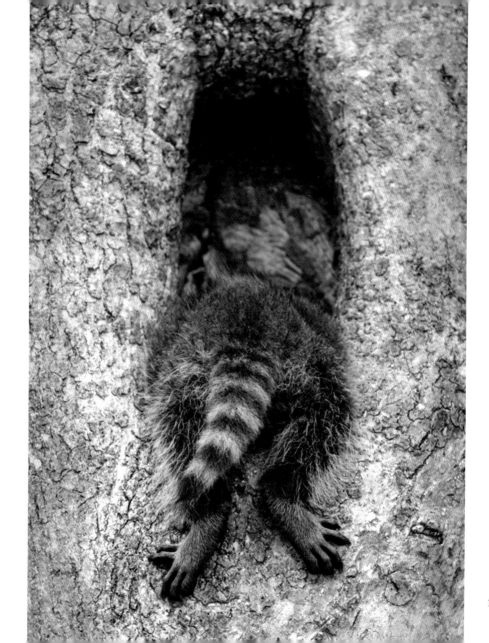

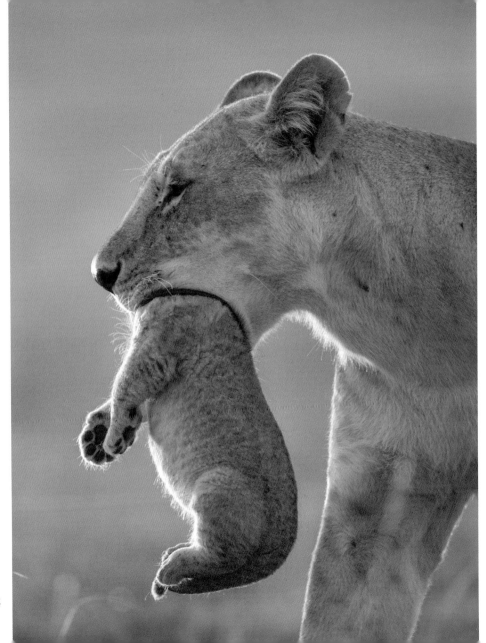

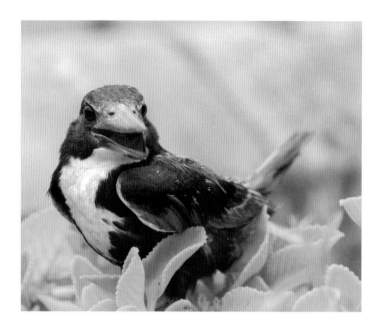

ANIMAL: Kingfisher
LOCATION: CHENNAI, INDIA
This kingfisher would be smiling from ear to ear, if she had ears.
PHOTOGRAPHER: Abu Galy

ANIMALS: Lion and cub
LOCATION: MAASAI MARA, KENYA
I wish mum would go to Specsavers.
PHOTOGRAPHER: Andreas Hemb

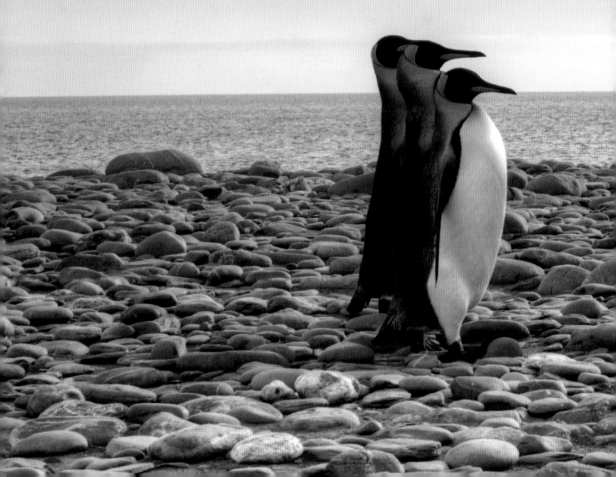

ANIMALS: King Penguins

LOCATION: SOUTH GEORGIA/SUBANTARCTIC

"Looking good boys, although it's a good job we don't need to make an effort to look smart for dinner."

PHOTOGRAPHER: Achim Sterna

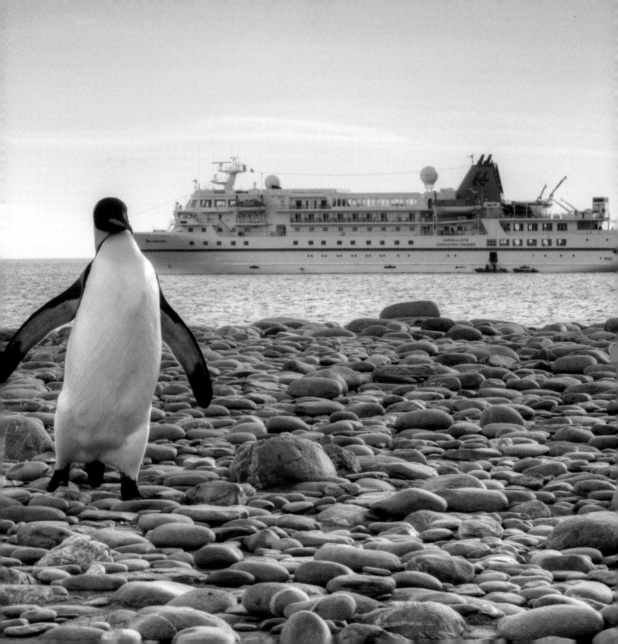

ANIMALS: Gull

LOCATION: EASTBOURNE

This gull's try-out for the RAF was going pretty well so far.

PHOTOGRAPHER: Adrian Ryan

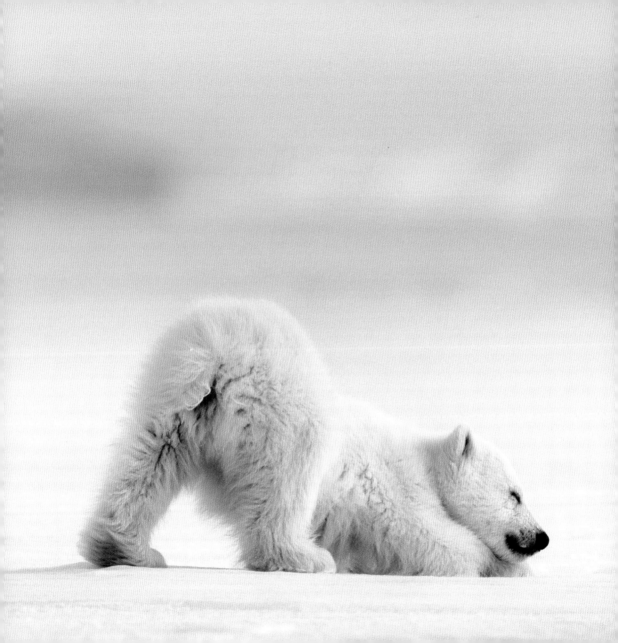

ANIMAL: Polar Bear

LOCATION: SVALBARD

Sometimes polar bear mums are so well camouflaged, you can't even see them.

PHOTOGRAPHER: Roie Galitz

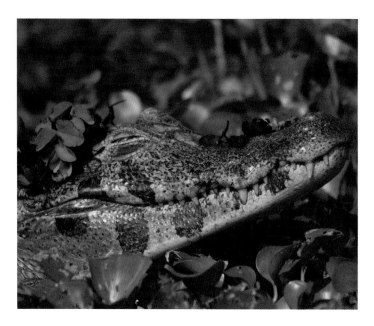

ANIMAL: Yacare
LOCATION: PANTANAL, BRAZIL
This time, Captain Hook's got no chance!
PHOTOGRAPHER: Barry Chapman

ANIMALS: Brown Bears
LOCATION: KUHMO, FINLAND
"Ah, so you're a southpaw?"
PHOTOGRAPHER: Ben Penson

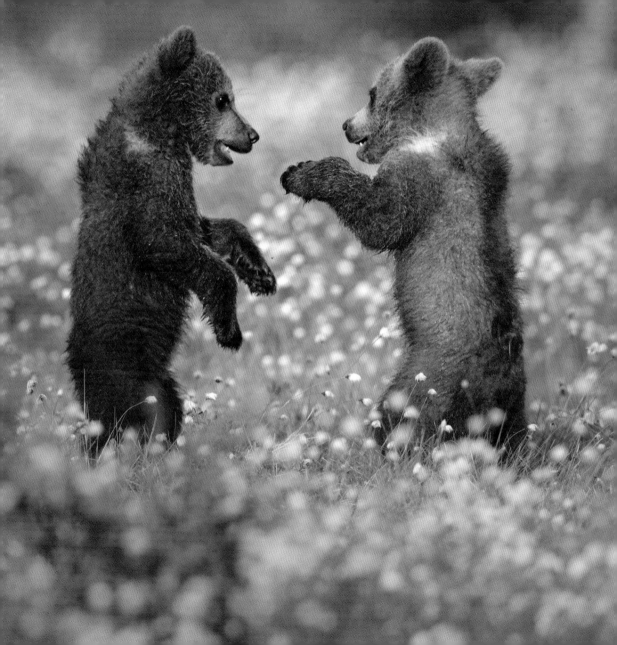

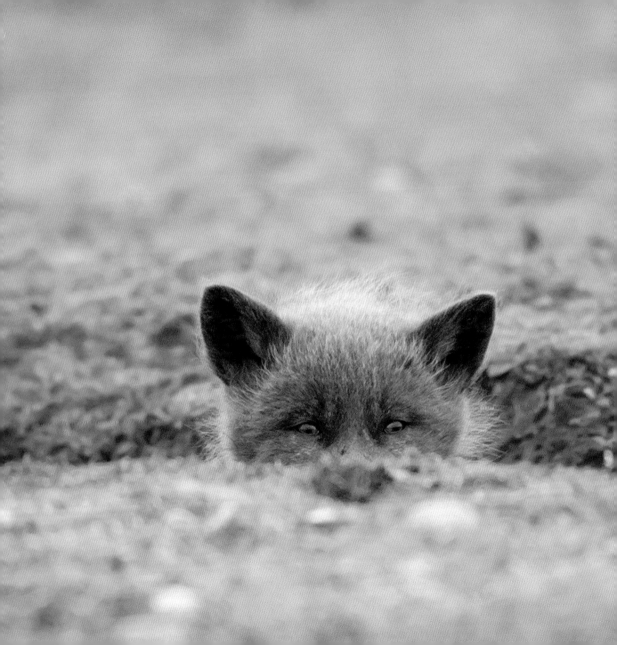

ANIMAL: Red Fox

LOCATION: WASHINGTON STATE, USA
Renard really wasn't enjoying this real-life version of whack-a-mole.

PHOTOGRAPHER: Benjamin Knoot

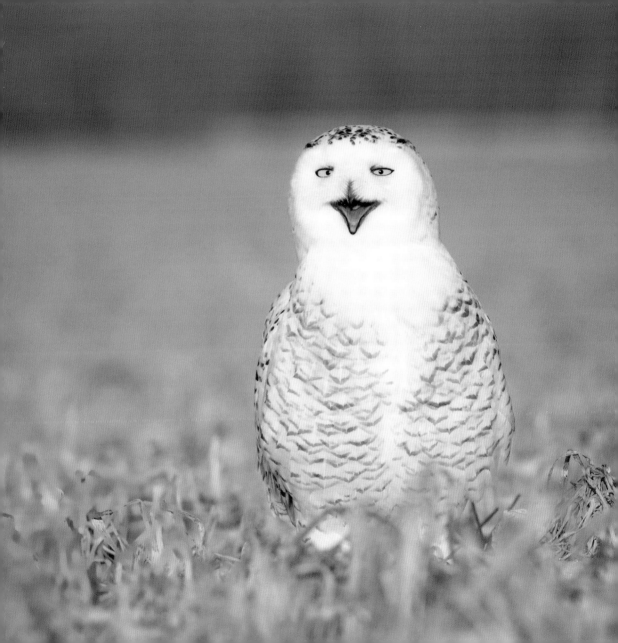

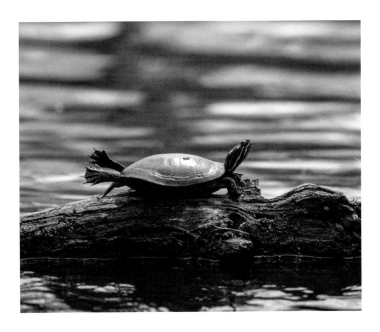

ANIMAL: Terrapin

LOCATION: WOBURN, MASSACHUSETTS, USA

This young terrapin is practising the Sun Salutation yoga asana.

PHOTOGRAPHER: Beth Rizzo

ANIMAL: Snowy Owl

LOCATION: ONTARIO, CANADA

What a hoot.

PHOTOGRAPHER: Bobo Bird

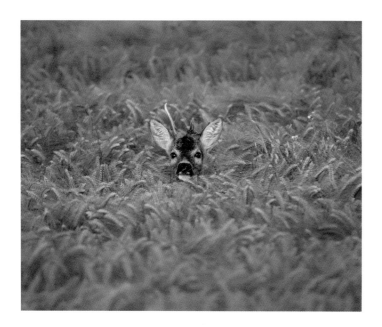

ANIMAL: Roebuck
LOCATION: STYRIA, AUSTRIA
Oh deer, it appears I've been rumbled.
PHOTOGRAPHER: Claudia Peschmann

ANIMALS: Mountain Gorillas
LOCATION: VIRUNGA NATIONAL PARK, DRC
"Why can't we have one nice family photo?"
PHOTOGRAPHER: Cameron Raffan

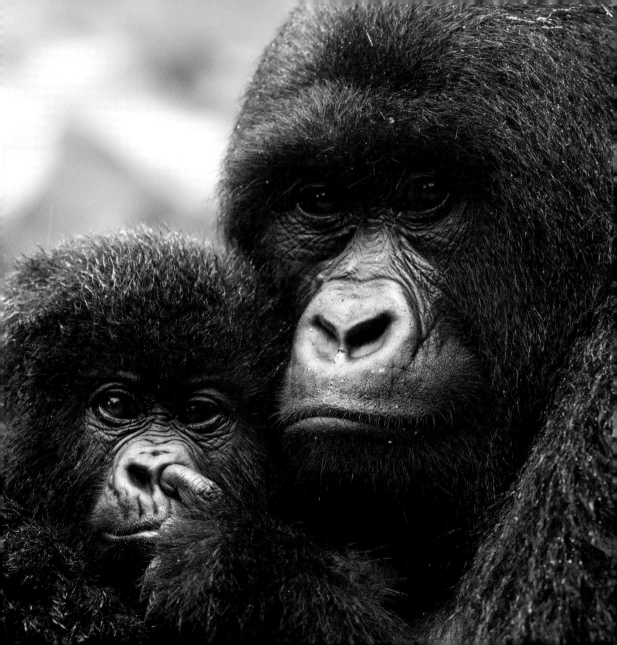

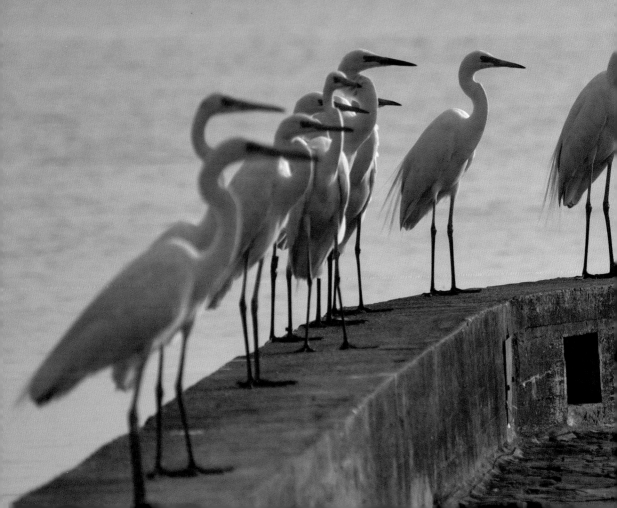

ANIMALS: Great White Egrets

LOCATION: SIÓFOK, HUNGARY

"Ladies and gentlemen of the jury, je n'egret rien."

PHOTOGRAPHER: Daniel Harcz

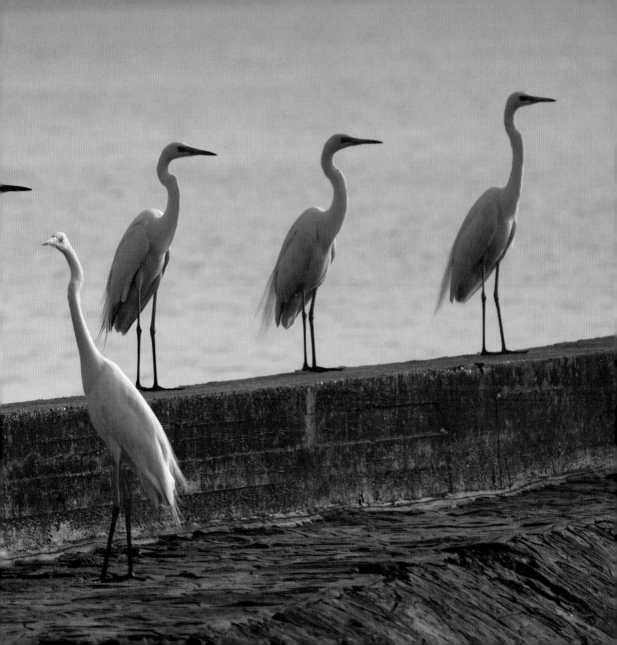

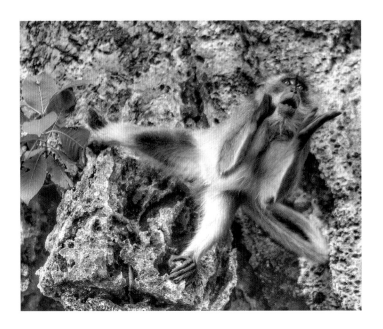

ANIMAL: Crab-eating Macaque
LOCATION: KOH PHI PHI LEH, THAILAND
The macaque cricket team really go the extra mile with their fielding practice.
PHOTOGRAPHER: Nicol Nicolson

ANIMALS: Hippopotamuses
LOCATION: MANA POOLS NATIONAL PARK, ZIMBABWE
Three beach bums.
PHOTOGRAPHER: David Fettes

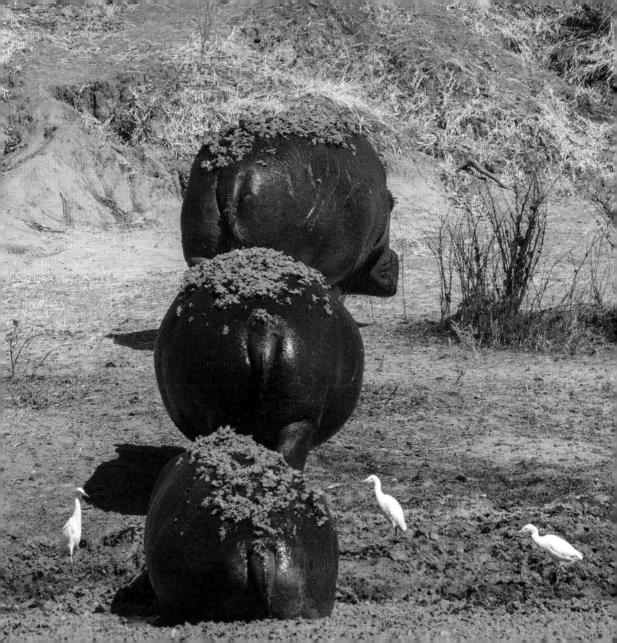

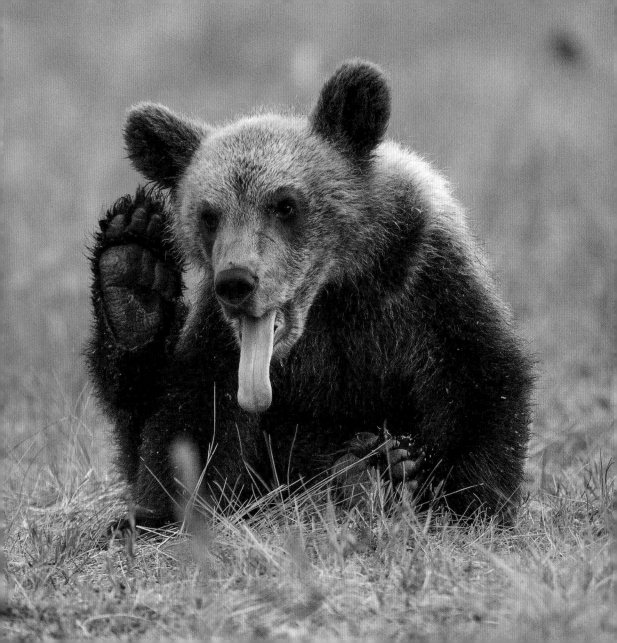

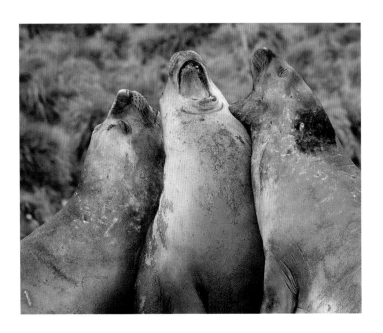

ANIMALS: Elephant Seals
LOCATION: SOUTH GEORGIA ISLAND
The Three Tenors perform O Lemon Sole Mio.
PHOTOGRAPHER: Eric Keller

ANIMAL: European Brown Bear
LOCATION: PIRTTIVAARA, FINLAND
Remarkably and appropriately, this is actually very close to the
Half Lord of the Fishes Yoga pose. The extra tongue stretch is
just showing off, frankly.
PHOTOGRAPHER: Gavin Foster

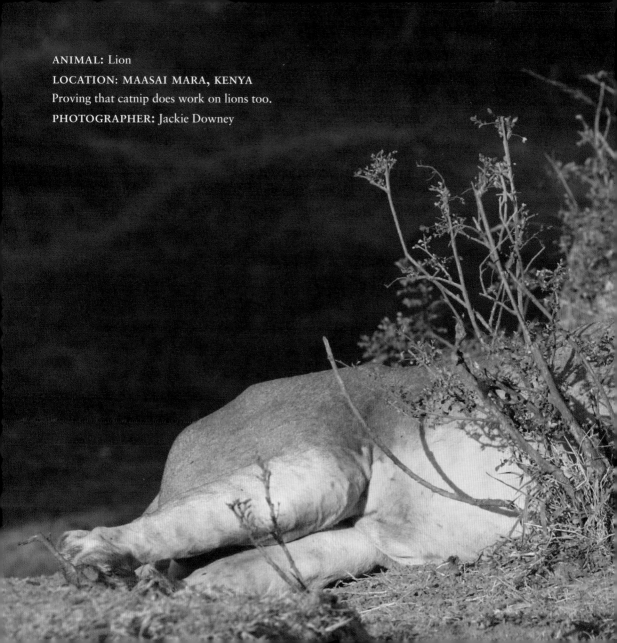

ANIMAL: Lion
LOCATION: MAASAI MARA, KENYA
Proving that catnip does work on lions too.
PHOTOGRAPHER: Jackie Downey

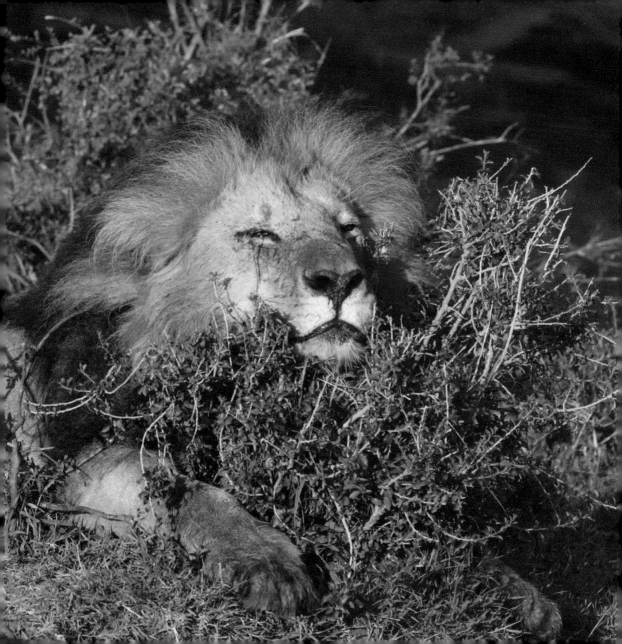

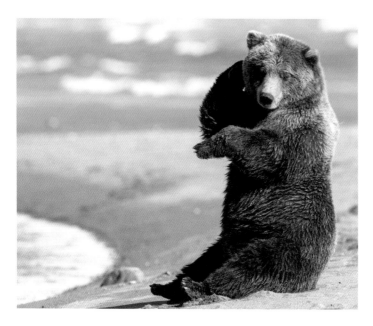

ANIMAL: Grizzly Bear
LOCATION: ALASKA
Sadly, Bungle's growing bald spot meant he had no choice but to apply suncream.
PHOTOGRAPHER: Daisy Gilardini

ANIMAL: Red Squirrel
LOCATION: CALGARY, ALBERTA
"Anyone got a light?"
PHOTOGRAPHER: Jonathan Huyer

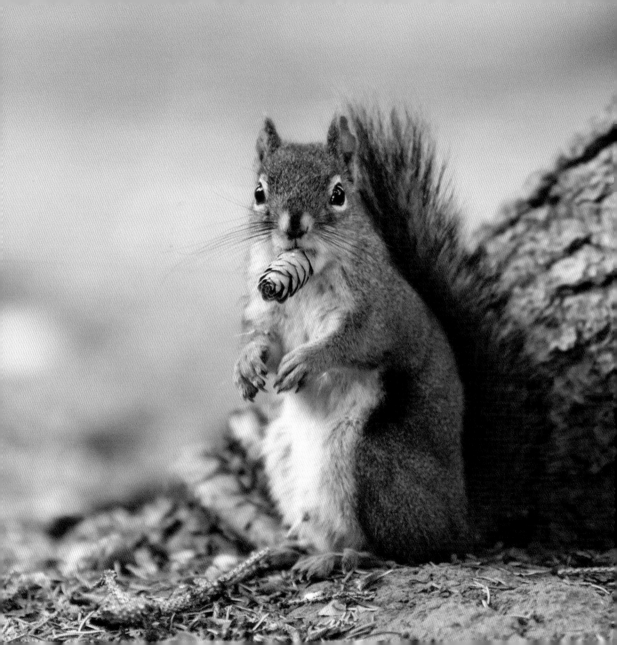

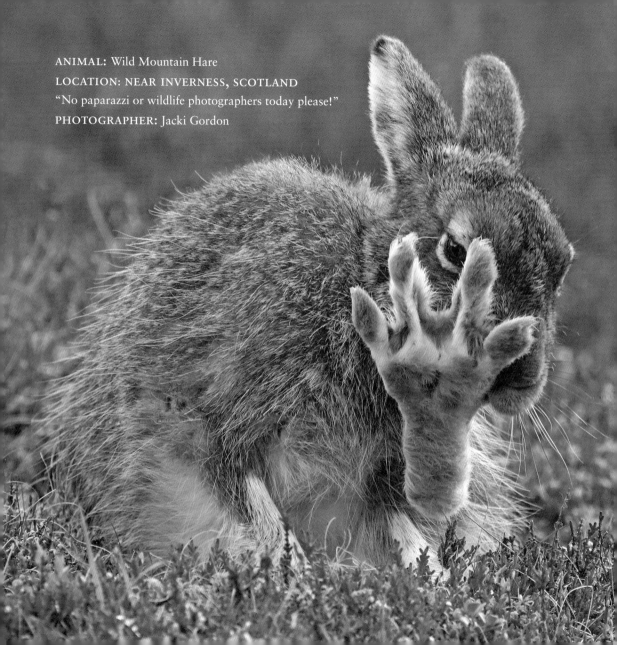

ANIMAL: Wild Mountain Hare

LOCATION: NEAR INVERNESS, SCOTLAND

"No paparazzi or wildlife photographers today please!"

PHOTOGRAPHER: Jacki Gordon

WHAT WE CAN DO AT HOME TO BE CONSERVATIONISTS

We all know that we could do more. We all know that we don't do enough. But we all also know that the life that we live and the world that we live in make it very difficult to avoid creating more rubbish and more pollution. We are the first to admit that it's impossible to be perfect – BUT... that doesn't mean we can't do our little bit, however modest, however seemingly token or futile... because it is not token, futile or modest. It is about making the small steps that lead to the giant strides. With that thought in mind, we have some useful tips for you all (and for us) to make those little steps. Spread the word, tell your children, tell your parents, and let's all move in the right direction together.

1. Shop responsibly – avoiding palm oil products, and un-recyclable products and packaging, buy the cucumber that's not wrapped up and choose the paper bag, or the long-life bag instead of the plastic bags on offer.
2. Restrict water use – don't flush your wee, have shorter showers, and maybe forget about baths altogether?
3. Become a 'conservation influencer' – it's a new term we've come up with, sort of like the celebrity thing, but with a conservation angle. The idea is not a tricky one, tell people what you are doing, encourage friends and families to do likewise, contact your

local councillors, MPs or government representatives about what they are doing, or ask whether they support environmental bills. The last couple of steps involve more time and effort, but putting pressure on those in power is valuable in itself.

4. Engage with conservation organisations, join your local wildlife trust, and support your local park. How? Follow them on social media, find ones you like and get onto email lists, support them financially and most importantly ask them questions about what they do and why.

5. How about getting a window box or two, for the pollinators of this world? So easy, and if you do it right, it can even look good!

6. Put up feeding stations for birds – try and get your school, or your children's school to have one. It's a win-win for everyone.

7. Travel responsibly – could you fly less and get the train more? Maybe not, but when you do go on holiday, avoid buying the big inflatable plastic flamingos… or similar one-use plastics.

8. If you are still reading, then amazing! Thank you! There are many things we can all do and the above ideas are some quick wins, but there are so many others. Share them, and hear what others do.

And last, but obviously not least, we love Born Free. We know them and they use their hard-earned resources extremely well and have made a genuine difference to wildlife across the planet. Both Tom and I have first-hand experience of the organisation. Support them if you can.

You can give at www.bornfree.org.uk/donate.

ACKNOWLEDGEMENTS

You would think that by the time the third book came along, acknowledgements would be a relatively short affair. After all, 5 years and 3 books would suggest experience and learning, and therefore less need for support, help, direction, correction and continual guidance. Sadly, both Paul and Tom need all of these. Much like a young baby learning to take its first steps and having its hands held, Paul and Tom wobble left and right, sometimes crashing into each other (to date they have not fallen) but invariable pulled from the edge by one of the many people that keep the machine on track.

Firstly, foremost, at the top, completely first, Michelle Wood. We may jest about our shortcomings, but this is one person that we won't jest about. Or not much anyway. Michelle has been the glue that wasn't there before. She joined our team last year and has been like a jackpot win for Tom and Paul. It isn't easy to say how grateful we are to her, so we won't go into it here, but very simply, a massive thank you is due to Michelle for everything. Thank you.

Our judges, Kate Humble, Hugh Dennis, Will Travers, Will Burrard-Lucas, Oliver Smith, Simon Pollock, Andrew Skirrow, Ashley Hewson, John Atkins and three fabulous new humans recently added to the Magnificent Judges Team: Bella Lack, an inspired, energetic and next generation conservationist – thank you for joining us: Celia Dunlop, quite possibly one of

The World's Most Brilliant Picture Editors, who can tell Paul and Tom, both professional photographers, what a decent image really is, and finally Our Man In The North – Henrik Tanabe, clearly a fabulous photographer and obviously (as he works with Olympus and has recently joined the Comedy Wildlife Team) very intelligent! The Magnificent Judges Team, all individually bring their own specialism, skill and insight to the judging process, and all elevate the competition to a level it would have struggled to achieve had it been left in our own shaky hands. Thank you, it really has been a pleasure, and we look forward to many more years working with you.

Our sponsors and Partners: The Born Free Foundation, Amazing Internet, Alex Walker's Serian, Spectrum Photo, Think Tank, Affinity and Olympus Finland, you are all utterly invaluable to the success of this photographic competition. To be able to offer the prizes we do, the exhibition and the website to make it all possible, has played a major part in helping reach so many people and increasing awareness of these animals. Thank you all for what you have done and what you continue to do.

Our literary agent Natalie Galustian, a fantastic source of knowledge and direction who continues to juggle Paul and Tom's myriad character flaws and help get the show on the road. Which very smoothly leads us onto thanking our publisher, Joel Simons at 535 and Blink Publishing, for performing a very similar role to Natalie's!

And finally, though by no means least, to our families – The Pooch, Tommy and Sammy on one side, and Kate, JoJo and Finn on the other side. They have been so tolerant of our late nights, early mornings, and general disappearing acts (to play golf) and not once have they shown any interest, exasperation with or doubt in our project. For that we owe them a lot more than we can ever pay back. Thank you.

<div style="text-align: right">

With much love to all of you,
Paul and Tom

</div>

ABOUT THE TEAM

PAUL JOYNSON-HICKS is a wildlife photographer, recently 'award-winning' to his great relief, although Tom still out 'awards' him, much to his delight. He lives in Arusha, Tanzania with his Mrs, (aka The Pooch) and his two small boys (aka the Bograts), and his Springers. He loves being in the bush and taking pictures. He was awarded an MBE for charitable work in East Africa over the last 25 years. He created the Comedy Wildlife Photography Awards to give Tom a chance to shine.

Having spent the first part of his professional life working in financial services in London, TOM SULLAM realised the error of his ways to quit everything, pursue a career in photography and help Paul reach greater heights than he already had. Tom won the prestigious Fuji Photographer of the Year award, along with the One Vision prize and then turned his hand to commercial photography. He moved with his family to Tanzania, met Paul, and the rest, as some say, is history.

MICHELLE WOOD is definitely not a photographer, (although, apparently, she does own a camera... somewhere) but has spent a lot of time researching, editing and commissioning other people's art and photography, which is why she has taken pity on Paul and Tom's inability to do much and now works with them. She lives in the middle of the Oxfordshire countryside, equidistant between a gin distillery and a brewery, with her family and devoted black Labrador Joey Trebbiani.

IN PARTNERSHIP WITH THE BORN FREE FOUNDATION

The Comedy Wildlife Photography Awards are proud to support Born Free, an international wildlife charity founded by Virginia McKenna OBE, Bill Travers MBE and their eldest son Will Travers OBE, following Virginia and Bill's starring roles in the classic film Born Free. The charity is devoted to wild animal welfare and Compassionate Conservation, working to save wild animals, stop suffering, rescue individuals and protect threatened species. Born Free is determined to end captive wild animal exploitation, phase out zoos and Keep Wildlife In The Wild. They take action to conserve and protect wild animals and work with local communities to find solutions that allow people and wildlife to live together without conflict.

Find out more and get involved at www.bornfree.org.uk.

amazing internet

Amazing Internet is a leading provider of websites for photographers and other visual artists. Creators of the original and best template-based website system for photographers: portfolioseries.co.uk

AFFINITY PHOTO

Fast, smooth and powerful, Affinity Photo pushes the boundaries for professional photo editing on Mac, Windows and iPad.

thinkTANK

Think Tank produces original innovative products that can handle all types of conditions experienced during the photographic process. Our philosophy is simple: Our products should help photographers "Be ready for the moment" TM

ALEX WALKER'S SERIAN

Alex Walker's Serian is a charismatic collection of exclusive and intimate safari camps in the prime wildernesses of Kenya and Tanzania. We operate and outfit safaris, and our focus is on offering you access to the magic of the bush in a rich variety of ways. www.serian.com

SPECTRUM

WWW.SPECTRUMPHOTO.CO.UK

Spectrum is a longstanding professional imaging lab specialising in high quality fine art and photographic printing, as well as archival mounting. www.spectrumphoto. co.uk

OLYMPUS

Technology meets design – Olympus' Camera and Audio business is dedicated to offering a wide selection of possibilities to capture and enjoy life's most precious moments. Olympus has a long history of combining innovative technology, usability and excellent quality with an extraordinary yet highly functional design.

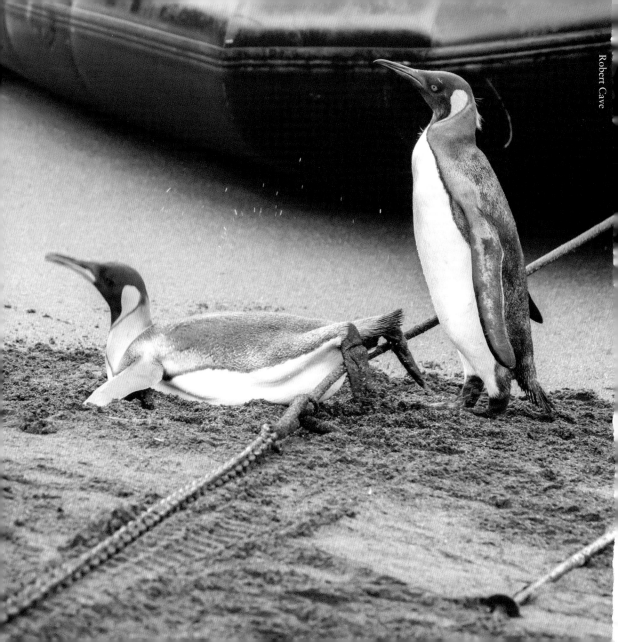